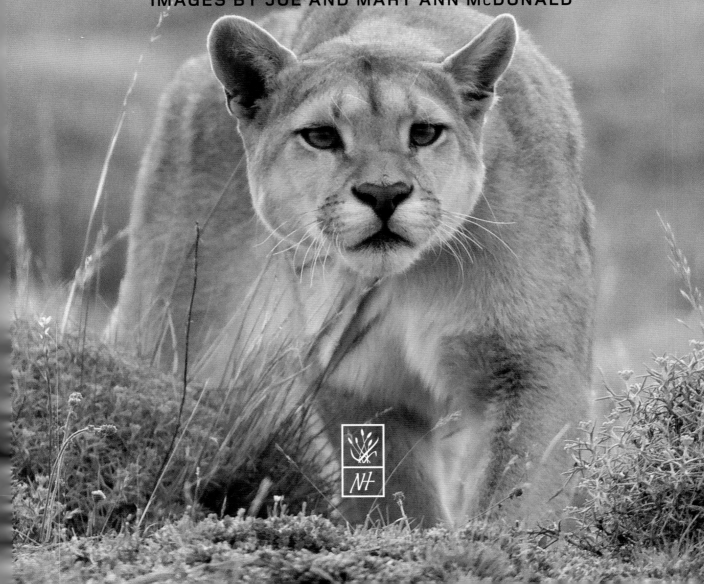

WORLD'S DEADLIEST CREATURES

TEXT BY JOE McDONALD
IMAGES BY JOE AND MARY ANN McDONALD

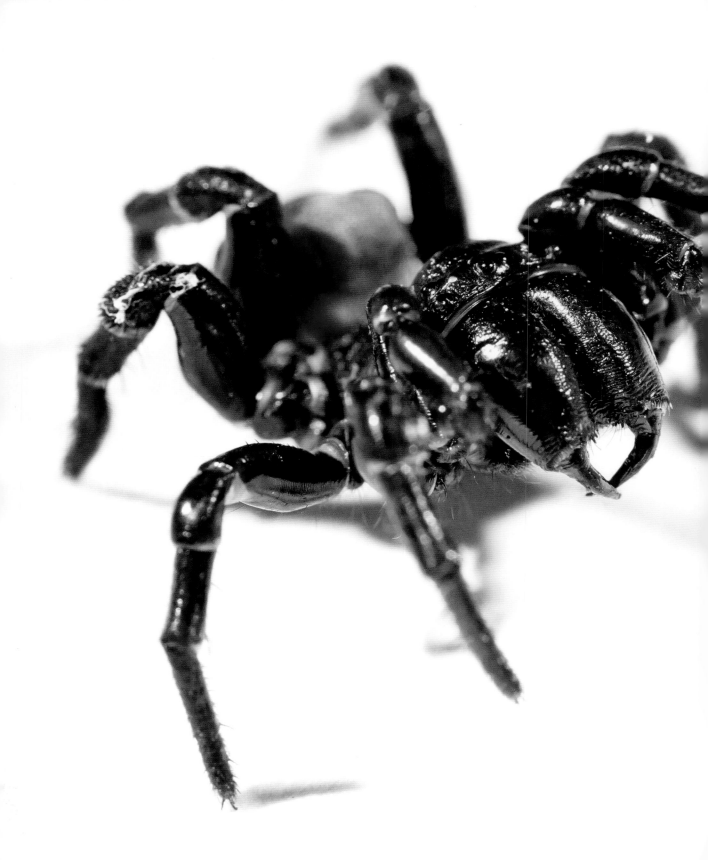

CONTENTS

INTRODUCTION

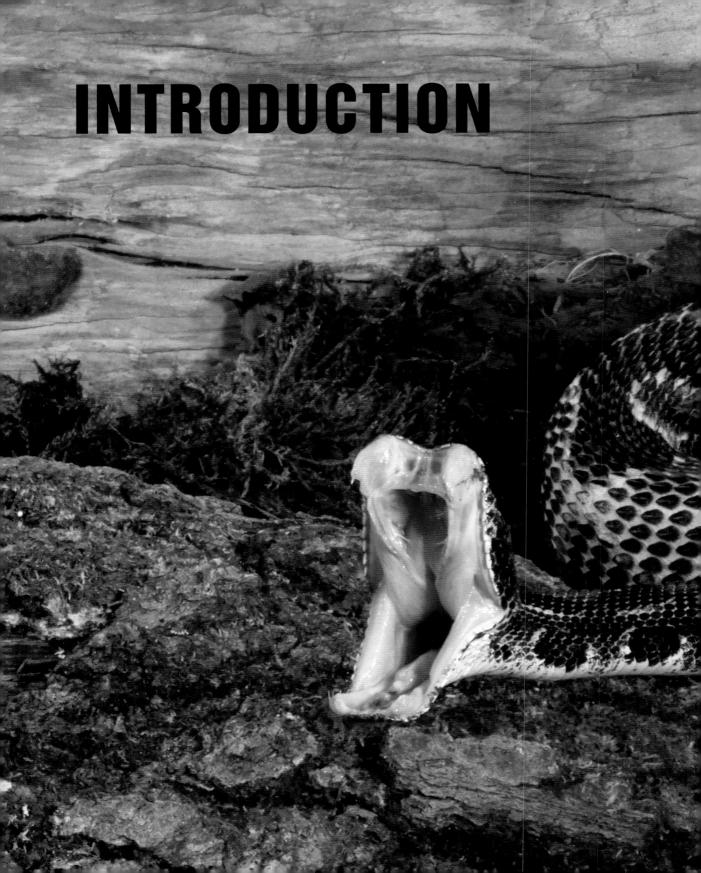

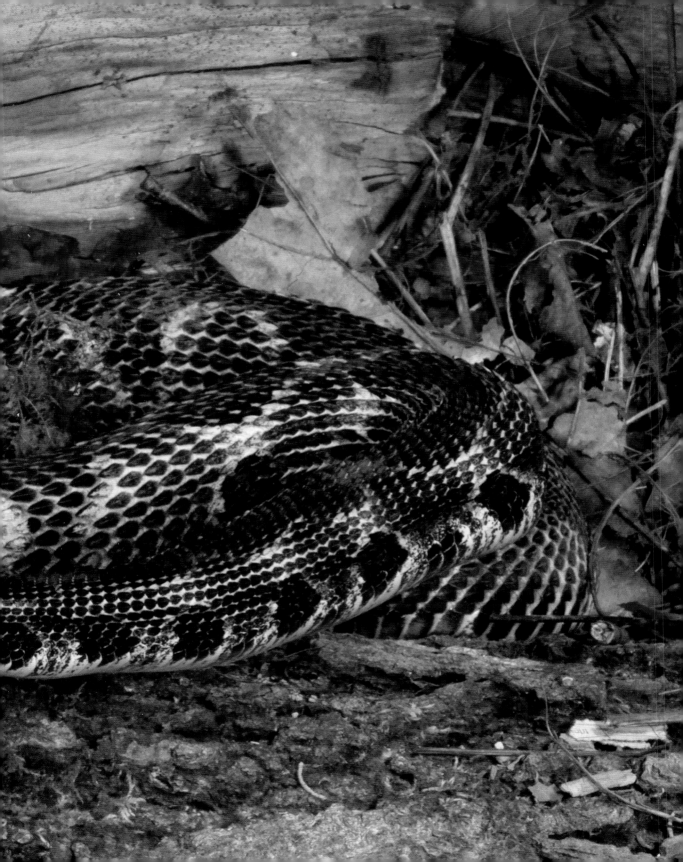

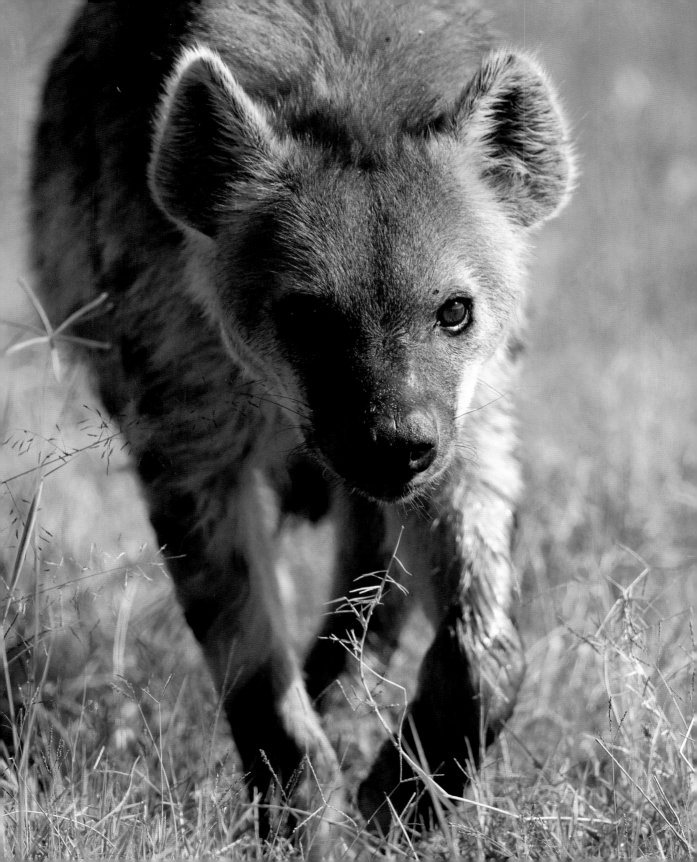

INTRODUCTION

The wild world can be a dangerous place. The power of the wind, the incredible and unexpected force of a sea wave, the strength of a river current, or the surprising action or response of a wild animal can instantly transform a beautiful or benign moment in nature into one of terror, or of doom. An adrenaline-filled adventure goes wrong, or the odd-looking critter that so intrigued you now bites or stings or charges and your world, your sense of place and superiority, suddenly turns upside down. It can happen in an instant and the result can be fatal.

This book is about some of the world's most deadly wild creatures, from the tiniest and most insignificant mosquito to the most imposing of all land mammals, the African Elephant. But this book isn't designed to frighten you silly or to imply that the wild world is a deadly place where wild animals lurk, just waiting to do you harm. With very rare exceptions, animals don't work that way, although rogue Elephants, hungry Crocodiles, wounded Bears or Buffaloes, or man-eating Lions, Tigers, or Leopards have done exactly that. For the rest, however, the danger they pose is a by-product of the adaptations and behaviours these animals have evolved to capture food and/or to protect them from being harmed or eaten, with human beings not being a part of that equation.

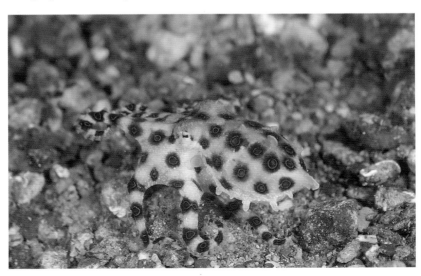

That said, many of the wild animals in this book are extremely dangerous, not because they might attack you unprovoked but because their natural defences truly pose a serious risk of death. Take, for example, a rather tiny coral reef resident of the Indian and Pacific Ocean. The Blue-ringed Octopus, growing no more than 20cm (8in) in total width, is an innocuous and well-camouflaged creature that displays distinctive blue rings when disturbed. For most predators, that's enough of a sign to leave this potentially tasty morsel alone, but if you persist, and the Octopus bites in self-defence, you're quite likely to die. In minutes. Of paralysis. There is no antivenom.

Sometimes the most innocent of human acts can result in tragedy. My wife Mary Ann and I have had a few close calls, usually because we were trying to do something good. One afternoon while Mary Ann was riding in a Land Rover on a game drive in Tanzania's Serengeti a beetle flew into the vehicle. It landed on the back of her hand and although she tried 'shooing' it away with a wave of her other hand, the beetle stayed anchored. Not really thinking, Mary Ann put her hand by the open window and leaned forward to blow the beetle off. As she did so, the beetle reared up and sprayed a scalding jet of fluid onto her face, actually blistering her skin. Luckily the spray missed her eyes, which could have caused

some very serious repercussions. Mary Ann didn't recognize that it was a Bombardier Beetle on her hand, an insect that ejects a concoction of two chemicals that, when mixed, reach temperatures close to boiling point.

As this anecdote illustrates, while we usually worry about the big wild animals, the Great White Sharks, the King Cobras, the Hippos, Lions, and African Buffaloes, it is often the little creatures which we tend to ignore that can be the most deadly. The ubiquitous *Anopheles* mosquito, transmitting malaria, probably causes more human deaths than any other animal. Some estimates put the death toll at nearly three-quarters of a million people per year. In all my interactions with wildlife it was an insect bite that probably brought me the closest to leaving this world. I had been bitten by a Tsetse Fly, an insect that can transmit trypanosomiasis, or Sleeping Sickness, and although the fly did not transmit that disease, the bite was irritating and I scratched it repeatedly, creating a small open wound. When I later visited a Maasai village, the wound got infected from the many flies that frequented the cow dung that was scattered about. That infection soon produced an orange-sized boil on my leg, and later necessitated a week of intravenous antibiotics in a hospital. I was lucky that the staph infection hadn't gone deeper or I'd have lost my leg and perhaps even my life from a systemic infection.

Most, but not all, deadly or potentially deadly encounters with wild animals are the result of something the human has done to precipitate unpleasant results. But sometimes accidents do just happen, as when someone steps over a log, and in doing so plants their foot on a resting snake. Many Pit-viper snakes hunt for mice by lying in wait beside mouse highways, the logs or branches these rodents use to run from place to place. Pit-vipers, like Rattlesnakes, Copperheads and Fer-de-lances, are quite cryptic and easy to miss when they are lying in wait for prey, and when stepped upon, the snake may strike in annoyance or in self-defence, and the consequences can be grave.

In well over 50 years of working with and photographing wildlife, ever since I was a small boy catching my first non-venomous Garter Snakes, I've only had an occasion or two where I felt in danger from a wild animal. One encounter that immediately comes to mind involved a bull Elk in Yellowstone National Park in Wyoming. I had been hiking in the open sagebrush country along a hillside when a herd of cow Elk came charging over the ridge, running past me as they fled their pursuer. A few seconds later the cause of their flight appeared, a large bull Elk that was fired up by the rut and intent on garnering some cows. The cows, meanwhile, had disappeared into a ravine. The bull charged by without giving me a glance but at the base of the hill he skidded to a stop, seemingly perplexed by the missing cows. The bull turned to retrace his steps, and that's when he saw me. Immediately the bull locked onto me and started advancing, head down and looking quite aggressive. I stepped a bit to my left to give him room to pass but the bull simply turned to keep me within his sights. I kept moving to the left but the bull stayed on me, steadily advancing closer. Luckily a large boulder and a small tree were nearby which I hoped would give me some cover, but the Elk began to circle those obstacles too. Now quite close, I grabbed a fist-sized rock, intending to at least try to deter the inevitable charge and hoping that I wouldn't miss, but luckily, a second or two later, the Elk turned and headed back up the hill. I didn't realize how scared I'd been until I started

walking, and found my legs were rubbery with the shakes. That was a very close call.

Elephants may kill upwards of 300 people per year, although most of those deaths probably occur when one of these large animals tramples a villager trying to drive a marauding Elephant from a crop field. That's not the case with bull Elephants in musth, a hyper-testosterone breeding condition, where an Elephant can become short-tempered and very dangerous. Once, the safari vehicle Mary Ann was riding in encountered such an Elephant. The Elephant charged, and Mary Ann's driver reversed course on the game track, with the bull in close pursuit. The trail made several twists and turns and the Elephant, instead of cutting a corner and closing the gap, stayed on the track and in doing so Mary Ann and the driver escaped unharmed. Had the Elephant made just one shortcut cross-country the story may have ended quite differently.

Mary Ann and I lead photo safaris all over the world, and on our trips to East Africa I always tell our tour participants that virtually everything 'out there' has the potential to kill you, from the lowly bug to the mighty Elephant, but how they do so will certainly differ. As my own experience illustrates, a bug bite might introduce a deadly infection or a microbe, while an Elephant might just grind you into the ground, leaving nothing but a grease spot on the plains. The information a tourist receives from guides can be misleading as well, and could get you into trouble. For example, some driver-guides or tour leaders may tell their participants that you are safe within a safari vehicle, at least from Lions and Leopards because these dangerous big cats don't recognize a human form inside a vehicle. Don't bet on it. If you watch closely, the big cats almost never give eye contact when you are inside a vehicle and stare past you, or, if their gaze sweeps by, the eyes just miss you as they do so. An annoyed or angry cat will in fact give you eye contact, and if you are on the receiving end of that deadly stare, question what you're doing, and get out of there, fast. I've had Lions and Leopards stare straight into the vehicle I was riding in, and every time someone in that vehicle was doing something wrong. Fortunately in every case we corrected the situation and avoided a charge, but a big cat serious about causing some damage can, as they have done in the past, jump inside a vehicle to bite or claw or otherwise maul a tourist.

As I stated earlier, this book isn't about deadly encounters filled with titillating stories of gore and mayhem. Instead, it is about these marvellous creatures, great and small, that possess some unique property that makes them dangerous to humans. These animals are fascinating in their own right, perhaps even more so since they are potentially deadly. We often think of ourselves as masters of the universe, kings of the world that we know, but as you meet the deadly creatures in this book that opinion may change and you may gain not only a better understanding of these animals, but also a more humbling perspective of our place in the natural world.

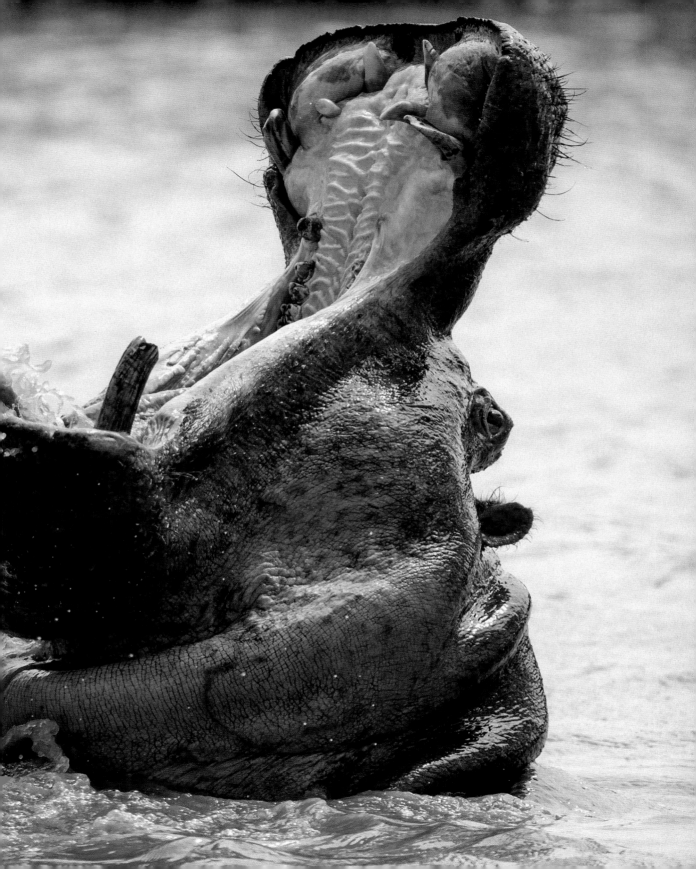

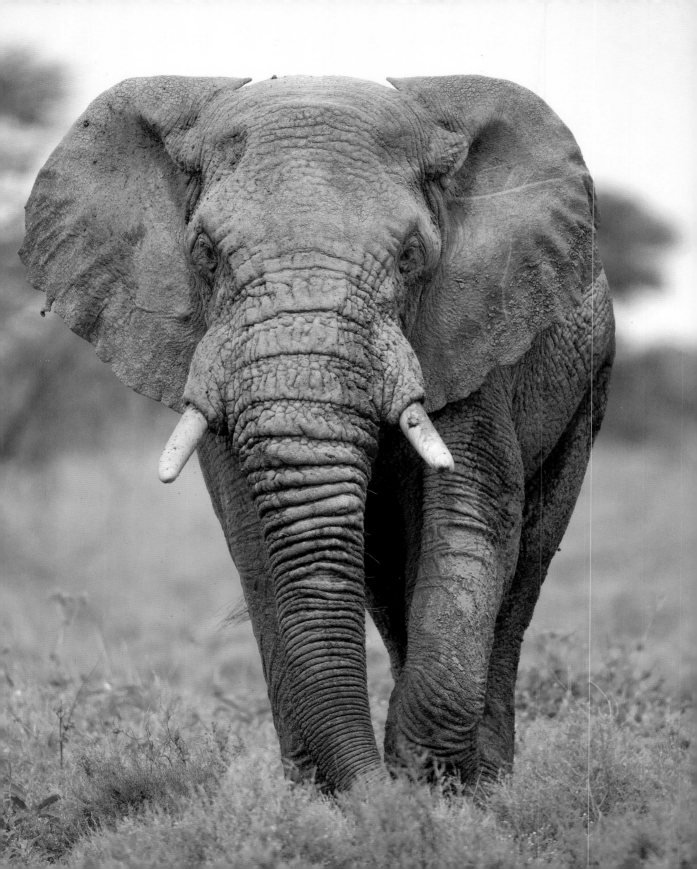

CHAPTER ONE
DEADLY MAMMALS

Of all the world's deadly creatures we can, as human beings, relate most closely to those that are our fellow mammals. Although some of us may be terrified of any animal that can do us harm others amongst us nonetheless respect, admire, and in some cases even revere these same creatures.

Prehistoric cave paintings dating back 12,000 years, from the end of the last great Ice Age, depict Lions, Bears, Mammoths, Woolly Rhinos and other animals, sometimes surprisingly realistically and accurately. Of course some of these mammals may have been food items, and the paintings may have recorded a hunt, but others, like the Lion and the Bear, were surely competitors, and doubtless also were grave threats to humans during this period. Carved figurines of mysterious human figures with a Lion's head, reminiscent of the Egyptian Sphinx, have been discovered in a few of these ancient caves. It is, of course, unknown whether the carvings are depicting a man wearing a Lion's head and cape, or is a representation of a Lion Man-God. Either way, I think it is safe to assume that the Lion was viewed in some sort of esteem, perhaps even revered, and this was at a time when meeting a Lion could very well end quite unpleasantly for the human!

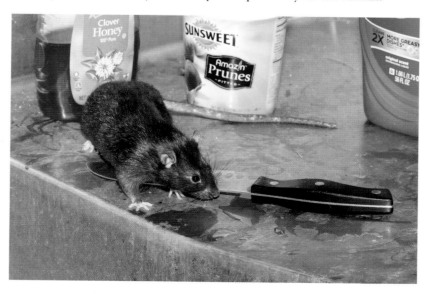

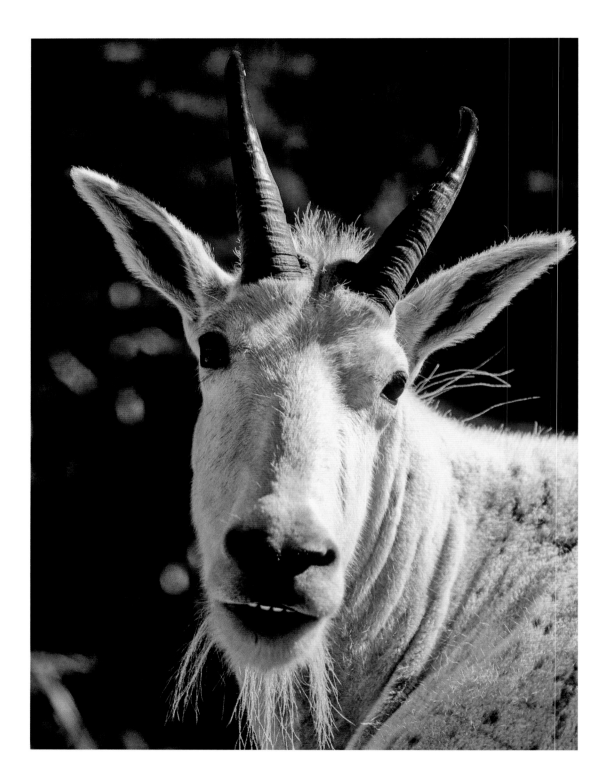

In some ways one could say that nearly every mammal has the potential to be deadly. One doesn't think of a tiny House Mouse, Pack Rat or Prairie Dog as capable of doing harm, but these rodents can carry the fleas which transmit Bubonic Plague. Indeed, the devastation of the 'Black Death' in parts of Europe and the Middle East during Medieval times was caused by Black Rats harbouring fleas bearing the plague. Prairie Dogs in the south-western United States occasionally carry plague-infested fleas, and cute little Kangaroo Rats and other small rodents carry another potentially lethal virus, the Hantavirus.

Bats are feared as carriers of rabies, and although most are free of the disease Bats can, because of their often crowded communal roosting sites, easily spread disease as they mutually groom. In Australia, Fruit Bats occasionally transmit a lethal virus to horses grazing beneath their roost tree, and the horses transmit the same virus to riders and stable personnel, often with lethal results to both horse and human. The source of Ebola, one of the most frightening of the viruses, is still unknown, but some evidence hints to a link with Bats, although that is yet to be determined.

Of course, some mammals are simply large enough to be deadly, especially when armed with potentially lethal accessories like horns, fangs or claws. In North America, more people may be killed by captive White-tailed Deer each year than by any other wild mammal. White-tailed Deer bucks, like their cousins the Elk and Moose, can become extremely aggressive during the breeding season and a previously 'tame' pet Deer can truly become deadly. Not too long ago a Mountain Goat, a beautiful white-furred resident of North America's western mountains that stands about 1m (3.3ft) at the shoulder, killed a hiker when the Goat charged and punctured the femoral artery of the unlucky victim. While a Mountain Goat does have spiky black horns, the animal is generally quite docile, and no one would expect to be mortally in danger from a goat. Yet it happens. Every year or so pet owners, of Bears, Tigers, Chimpanzees or any number of other large mammals that belong in the wild, are killed by animals they may have treated as loving, exotic companions, disregarding their potential to exhibit, even for an instant, their lethal instincts.

Not surprisingly some of the deadliest mammals are top predators, and Grizzly Bears, Tigers, Lions, and Leopards must be respected as potentially deadly animals. In India, individual Tigers and Leopards have been responsible for killing scores, and sometimes even hundreds of people, sometimes terrorizing a region for years. In Kenya, a pair of male Lions, the 'Man-eaters of Tsavo,' temporarily halted the construction of the railroad linking Nairobi, the capital, with the coast before finally being hunted down by a tenacious railroad employee.

Except for the rare man-eating big cat, most mammals do not purposefully set out to harm humans. But even so, deadly encounters do occur, and caution and respect must always be foremost in anyone's mind.

DEADLY MAMMALS
THE SPECIES

African Elephant
Loxodonta africana

The largest of all land mammals alive today, African Elephants once roamed throughout most of the continent of Africa. Today their population numbers under 500,000 animals, and because they are poached for their valuable ivory, perhaps at a rate of 100 elephants per day, they are in serious danger of extinction. An increasing human population has reduced their forest and grassland habitat and replaced it with farmland, creating inevitable confrontations and causing at least 100 human fatalities each year. When provoked, it is said that there is no escape from an angry Elephant. If you climb a tree, they will knock it down; if you dive into a warthog burrow they will dig you out; and if you run, they will surely catch you. Each year scores of tourist vehicles in African game parks are charged, but fortunately nearly all of these are merely threat displays and the elephant pulls up short.

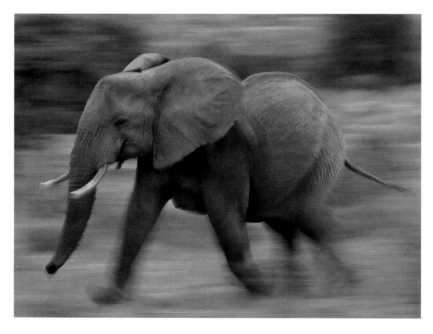

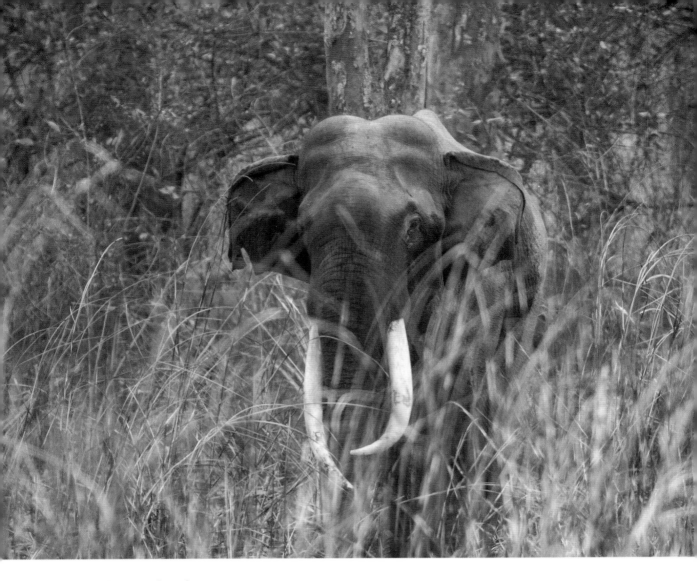

Indian Elephant
Elephas maximus

The Indian Elephant is the familiar circus animal trained to sit up, balance on two legs or do other tricks, but this seemingly tractable animal can be extremely dangerous. Trainers and innocent bystanders have been killed when an Elephant panicked and ran amok, just as villagers in India and elsewhere in Southern Asia are often trampled and gored when an Elephant is frightened while raiding crops. Male Elephants of both species can be extremely dangerous during the musth, the heightened sexual period where bulls seek mates and fight other males for breeding rights. Because of the density of the human population in India, deadly encounters with crop-raiding Elephants are even more common than in Africa.

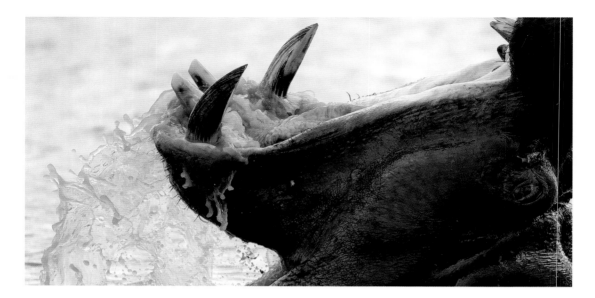

Hippopotamus
Hippopotamus amphibius

Surprisingly, the most dangerous mammal in Africa may be the chubby, lumbering Hippo, but records are unreliable and often anecdotal, and Elephants and African Lions may, in fact, account for more deaths per year. Hippos spend their days in lakes, ponds and rivers, but at night they leave the safety of the water to forage, chomping and plucking grasses as far as ten miles away from their daytime sanctuaries. At dawn they return, where they may meet a villager gathering water for the day, fishing or walking a path to a farm plot. A frightened Hippo may charge, and with its huge canine tusks, called tushes, a Hippo can practically bite a human in half. Most attacks by Hippos that take place on land end with fatalities, although Hippos can also be very aggressive when in the water as well, attacking and capsizing the boats of those unfortunate enough to get too close or who failed to see an angry Hippo's bow wave as it swam in to attack.

Black Rhinoceros
Diceros bicornis

Black Rhinoceroses have poor eyesight, and perhaps to compensate for their lack of vision they often react to any potential danger by charging. The third largest land animal in Africa, Rhinos can run at surprisingly speeds, perhaps 56km/h (35mph), and are not reluctant to smash their horn into or through a safari vehicle. The Rhino's formidable weapon is composed of keratin, the same protein structure that builds both our fingernails and our hair, but sadly this horn is erroneously credited with medicinal and aphrodisiac properties and is ruthlessly poached for this commodity. Rhinos are critically endangered, and in Southern Africa in 2014 a Rhino was poached approximately every 18 hours, a death rate that is simply unsustainable. For a Rhino, humans are most certainly the deadliest creature.

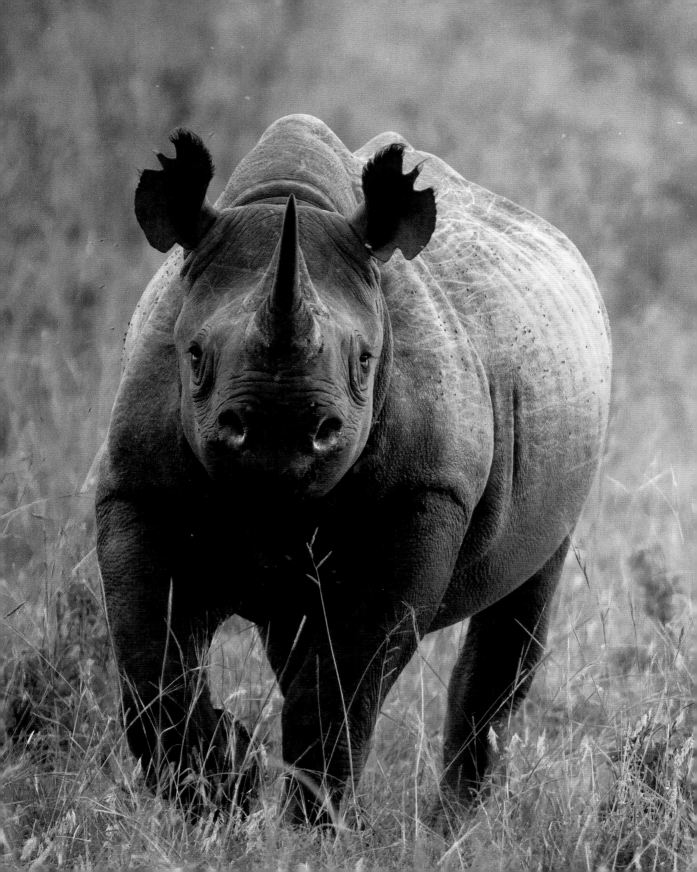

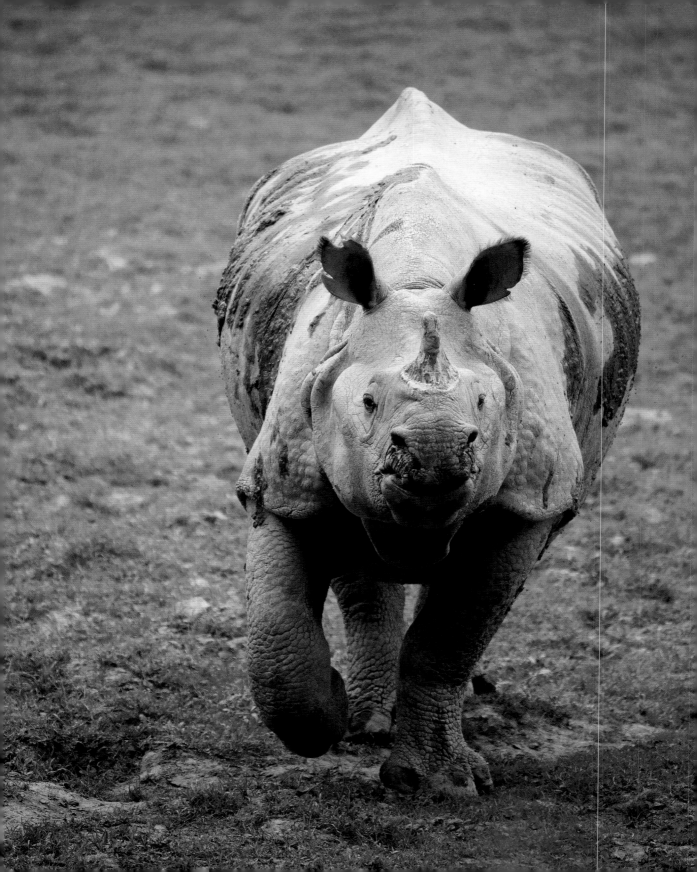

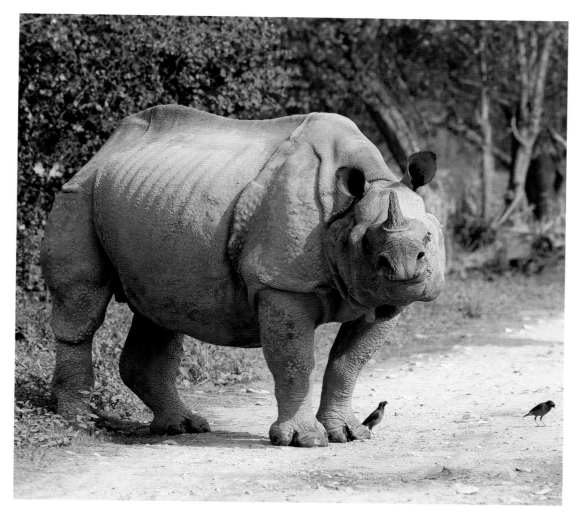

Indian Rhinoceros
Rhinoceros unicornis

The horn of the Indian Rhinoceros of northeastern India and southern Nepal is much smaller than that of either of its two African cousins, the Black Rhino and the White Rhino, but this species has a special weapon of its own. Indian Rhinos have large, sharp canine teeth which they may use in lieu of horning a victim, and the bite can be deadly. Armour-plated and somewhat resembling a dinosaur or some other relic of the past, Indian Rhinoceroses can be extremely short tempered and may charge and pursue a person on foot with deadly results.

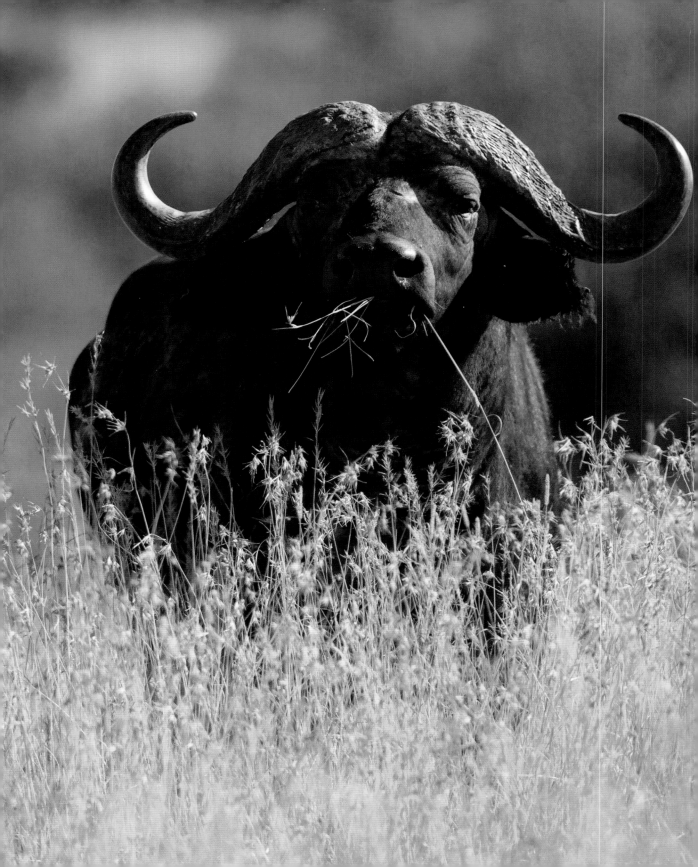

African Buffalo
Syncerus caffer

One of Africa's 'Big Five', along with the Lion, Leopard, Black Rhinoceros and African Elephant, this large herd animal would rather run than fight. However, when wounded Buffalo have been known to double-back and charge a hunter from ambush. Huge and powerful, Buffalo have been surprised by tourists wandering off into the brush, resulting in serious injury when the tourist was tossed by a hook of the Buffalo's sharp, curved horns. Some estimate as many as 200 human fatalities each year from Buffalo attacks, although that number is probably inflated. Still, the African Buffalo is formidable, and a bull is quite likely to turn the tables on a stalking Lion pride, chasing the Lions for hundreds of yards. A Lioness caught inside the deadly circle of a herd has a high likelihood of being killed, and once horned, the Buffalo will repeatedly toss a 135kg (300lb) cat into the air like a rag doll.

Elk
Cervus canadensis

One would think that everyone would give an animal equipped with long, sharp antlers a wide berth but every year, in several western parks in Canada and the United States, people are charged and gored or their vehicles damaged by pugnacious bull Elk. During the rut, the normally placid and retiring Elk becomes aggressive as it fights for dominance over other bulls for possession of a harem. Tourists in Yellowstone sometimes stop their vehicles beside a strutting bull, hoping for a quick photo, and in doing so provoke the Elk to charge. It is a fairly common to see a car smashed, with windows broken or holes poking into doors or side panels – evidence that an angry Elk was pushed beyond its tolerance.

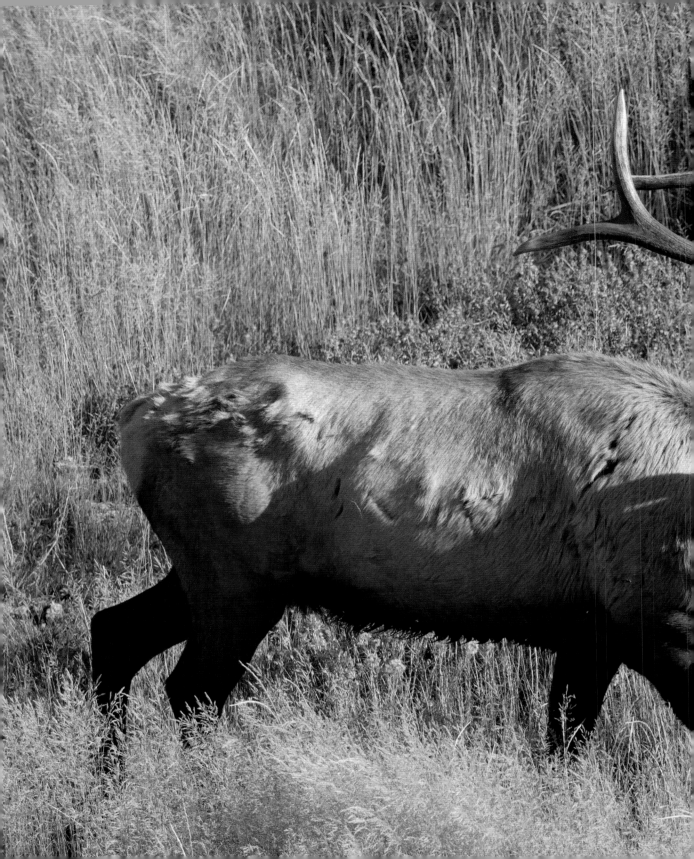

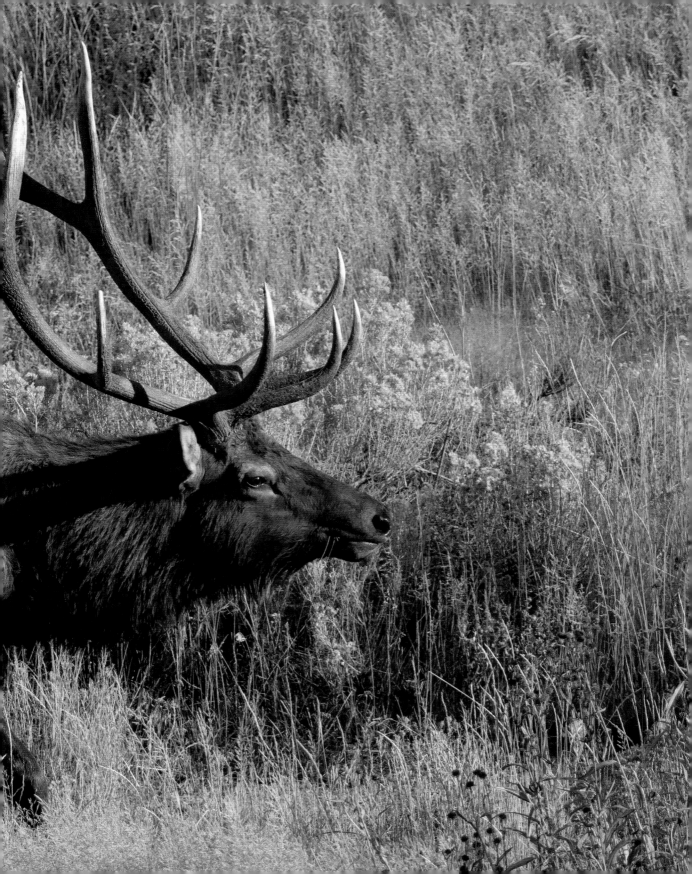

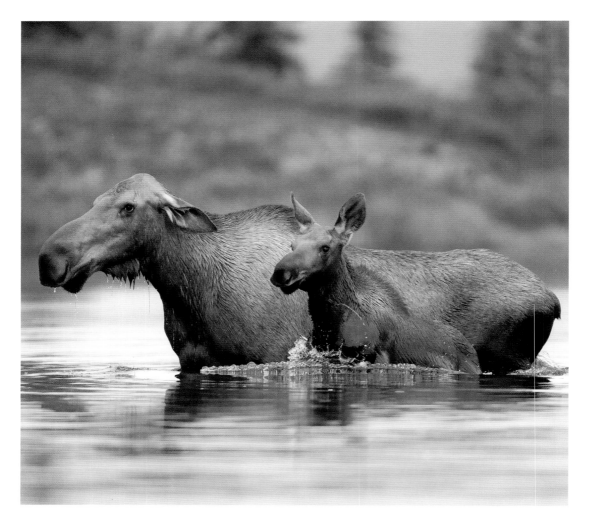

Moose

Alces alces, female with calf

Experienced outdoorsmen view a mother Moose with a newborn calf as one of, if not the most dangerous animal in the northern forests. Moose are generally timid by nature, but a female can be extremely protective of her calf, charging and boxing with her front legs to ward off any threat. A kick from her saucer-sized hooves could be fatal. Incredibly, because Moose seem to be so timid and easy-going, suburbanites around Anchorage, Alaska, where Moose are common and seemingly tame, sometimes try cornering, riding or otherwise harassing this nearly seven-foot tall animal, resulting in serious injury or death to the idiot attempting the manoeuvre.

American Bison

Bison bison

The iconic animal of the American west, the Bison, or 'Buffalo' as it is frequently and incorrectly called, seems like a mellow, cow-like beast. Nearly every year in Yellowstone National Park naïve tourists approach a Bison too closely, hoping to photograph themselves beside this massive animal, and get themselves killed by doing so. It has even been reported that parents have attempted to put their children on the backs of Bison for a photo. The results are often disastrous, as a Bison can move fast, and with its massive head and powerful neck and shoulder muscles, it can easily toss a human 4m (12ft) into the air. In 2015 alone, five people were very seriously injured by Bison when they approached too close. One tourist, hoping to have herself photographed beside a bull, stood only six feet away when the annoyed animal rose and nearly killed her.

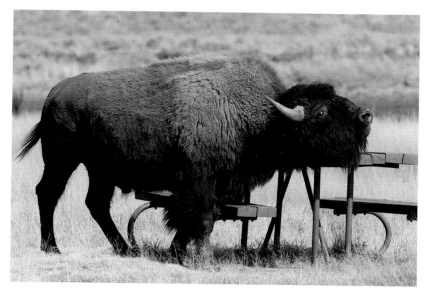

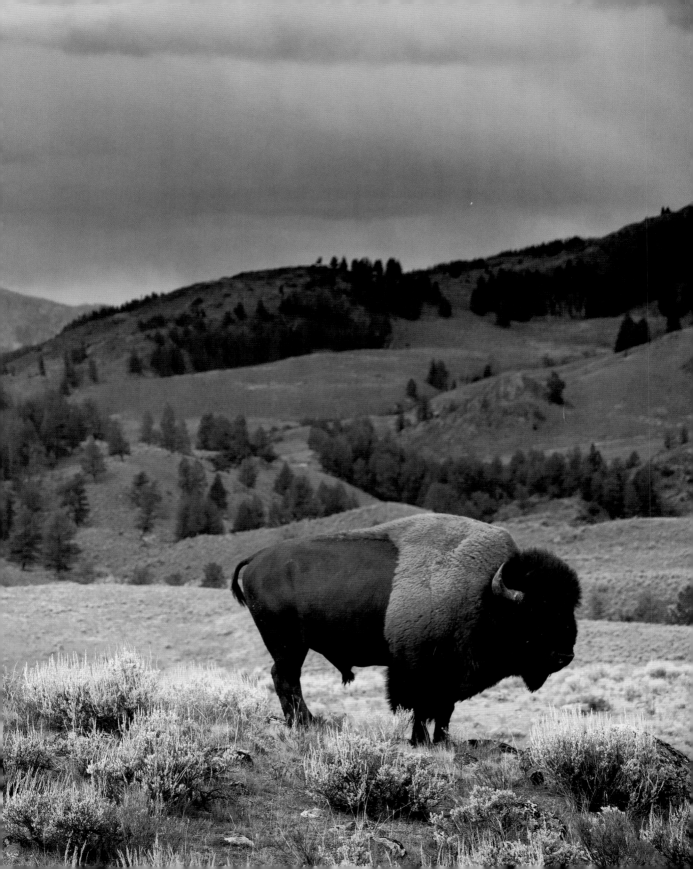

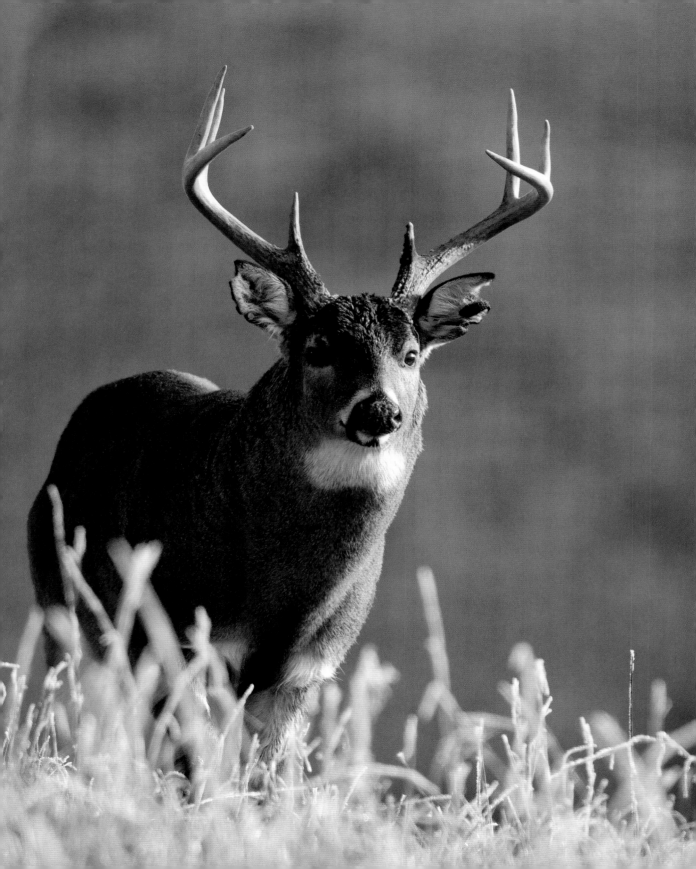

White-tailed Deer
Odocoileus virginianus

There are probably more White-tailed Deer living in the eastern United States today than existed when the continent was first settled by Europeans. That said, at the beginning of the 20th century deer were, if not in danger of extinction, still quite rare and in need of protection, as over-timbering and over-hunting had severely depleted their numbers. With game laws and habitat recovery deer populations bounced back, and as suburban developments carved up wild habitats, deer actually prospered, as wild predators and hunting disappeared in these areas. In many areas deer have become nuisance animals, eating garden plants and destroying landscaping, but they are deadly for another reason. Today, deer pose a serious threat due to the many traffic accidents which they are involved in. Anyone living in deer country, which today includes both rural and urban areas, has either hit a deer, come close to doing so, or knows someone who has. A struck deer may end up breaking through a windscreen, or cause a vehicle to swerve, leading to serious injuries or death. On average there are over 100 fatalities each year in the USA alone. 'Pet' bucks, even those hand-reared from fawns, can turn deadly during the rut, going from a placid companion to a lethal threat overnight, and captive White-tailed Deer also kill a few people every year.

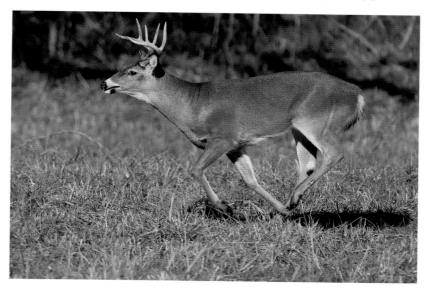

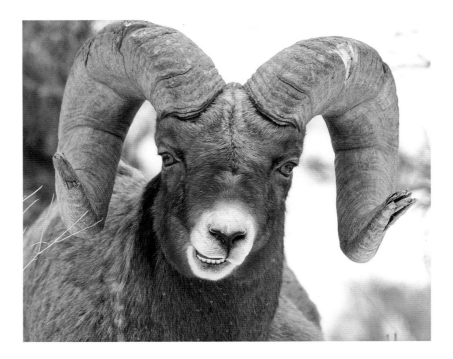

Mountain Goat
Oreamos americanus

Mountain Sheep
Ovis canadensis

In North America's north-western national parks Mountain Goats and Bighorn Sheep are common and tame, and often frequent the parking lots of Glacier National Park and the roadsides of Banff, Jasper and Waterton National Parks. During the rut, however, any large-hoofed mammal may be dangerous, as the hormones that prompt the males to fight for dominance and mates may direct an animal's attention elsewhere. On a mountain trail, with nowhere else to go, a hiker encountering a Sheep or Goat in rut could be charged and knocked off a cliff, or fatally gored. Mountain Goats were introduced into Olympic National Park before the park's creation. This is an area where natural salt licks are unavailable, so the Goats, craving salt, have become real nuisances, eating campers' socks and shoes, and often acting quite aggressively towards humans as they seek salt. Recently, a hiker in Olympic National Park encountered one of these overly aggressive Goats, and was fatally gored in the process.

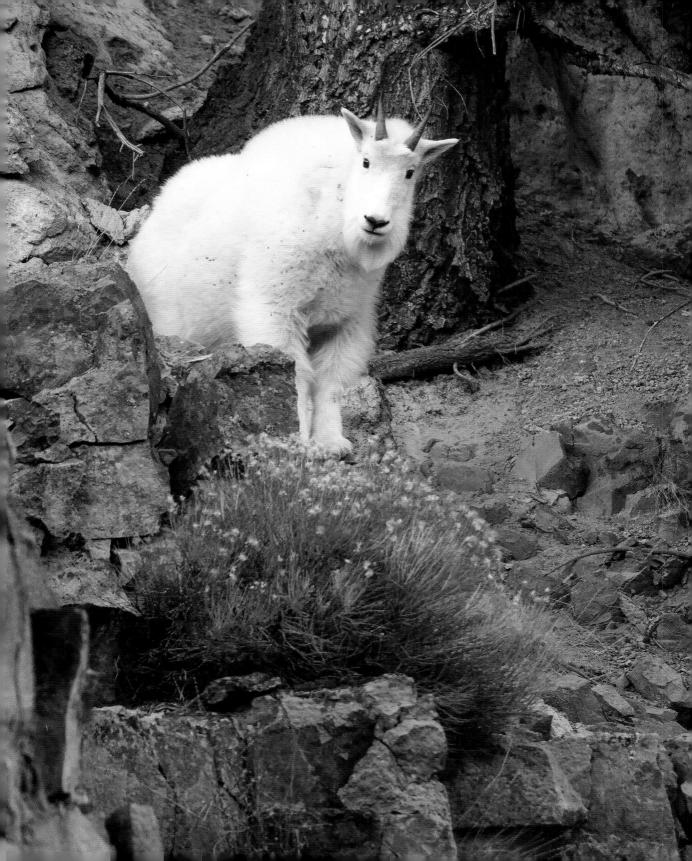

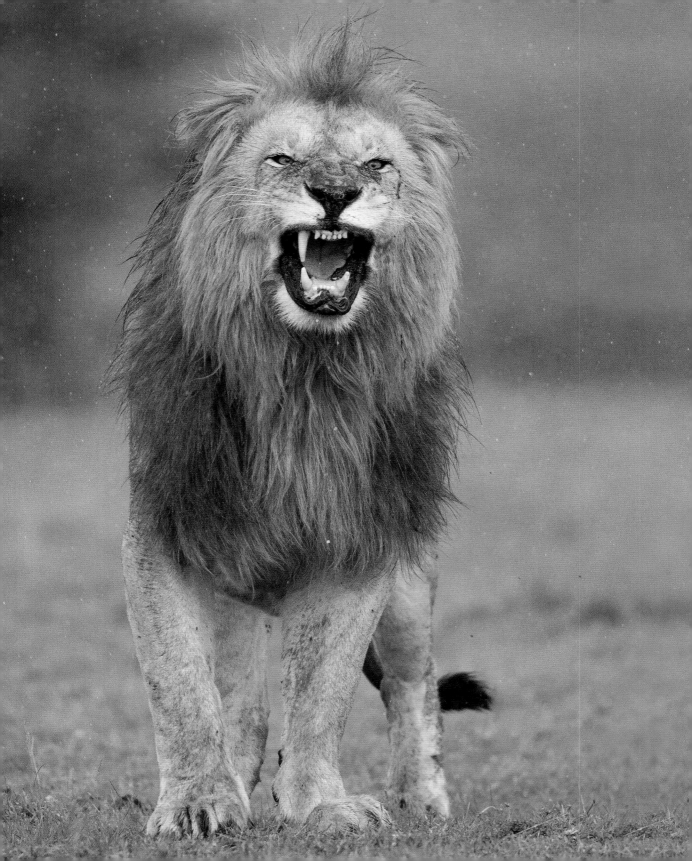

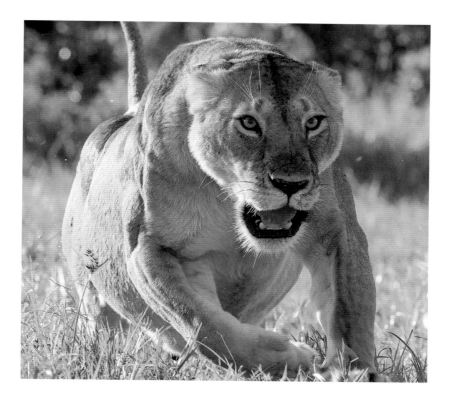

African Lion
Panthera leo

Perhaps the most famous deadly African Lions were the two deemed the 'Man-eaters of Tsavo,' which in 1898 so terrorized the Indian workers employed to construct a railroad bridge in south-eastern Kenya that they fled, and construction was suspended for several months until the big cats were finally hunted down. The Lions were reputed to have killed as many as 135 workers, but recent studies suggest this number was exaggerated, and 28 to 35 victims is the more likely number. Lions still kill people today, perhaps as many as 300 people a year, and it is likely that mysterious or unexpected disappearances of farm workers may often be due to a lion attack, and not from skipping out from a job or deserting a family. The threat from African Lions is rapidly diminishing, however, as Lion numbers have plummeted in the last 50 years, from perhaps 200,000 animals to less than 30,000, and possibly as few as 20,000 Lions still alive in the wild today. Sadly, it is now believed that soon viable Lion populations will exist in only a few of Africa's largest game parks and reserves.

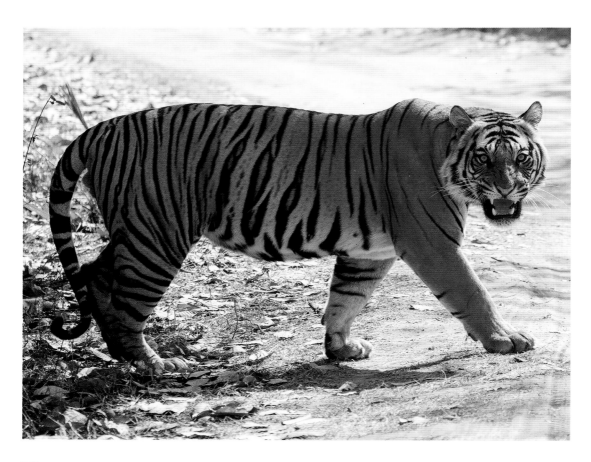

Tiger
Panthera tigris

Although once common throughout much of Asia, from Turkey to Bali and north into Siberia, Tigers are now an endangered species found only in India, extreme eastern Russia, and a few locales in mainland South-east Asia and Sumatra. Even today, however, Tigers still kill several people each year, with estimates ranging from 50 to perhaps as many as 200 in India. A century ago, Tigers posed a significant threat to the rural people of India, and a dozen infamous Tigers and Leopards alone were credited with over 1,500 deaths. In the Sundarbans of eastern India Tigers are still intensely feared, and the local fishermen and wood collectors there often wear a mask on the back of their head to deter a Tiger attack, in the mistaken belief that Tigers only attack from behind.

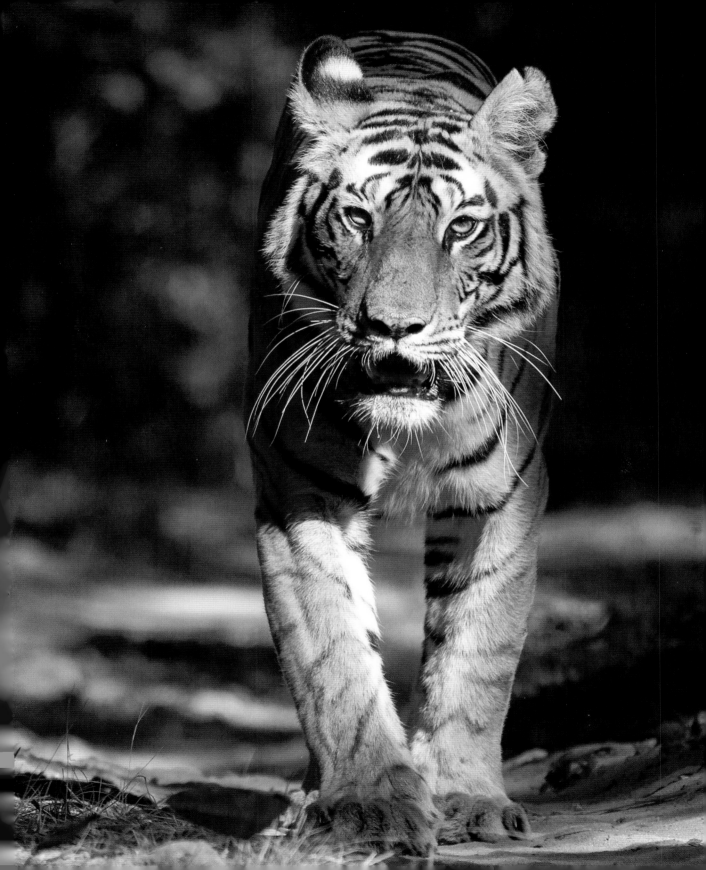

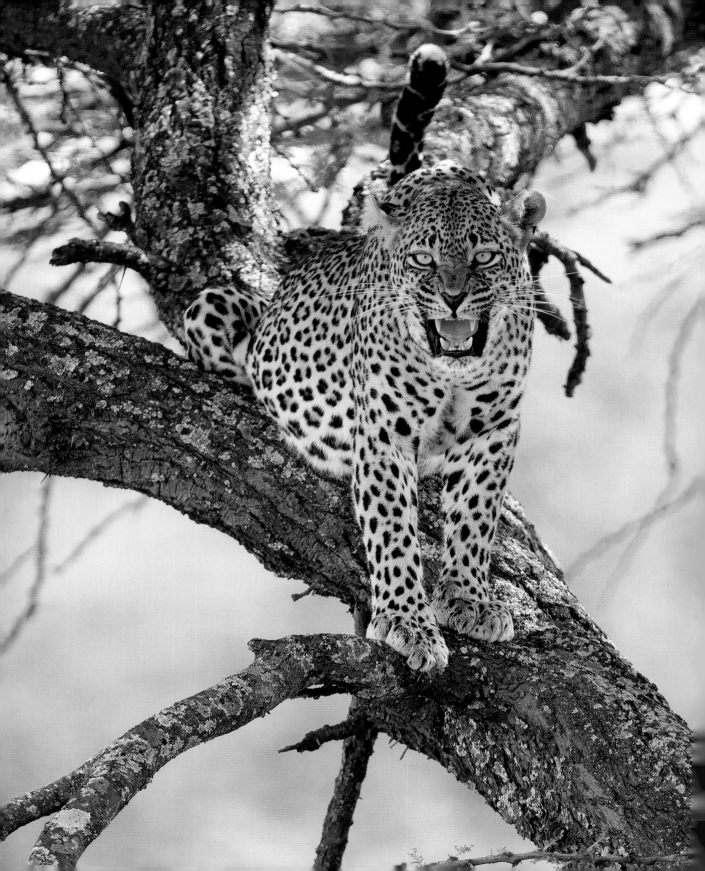

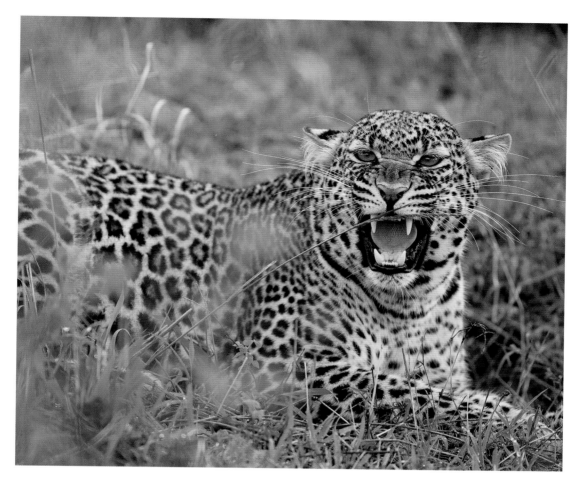

Leopard
Panthera pardus

The Leopard is the ultimate survivor, capable of living in marginal habitats that could not support a larger big cat. They are found in the outskirts of Nairobi, Kenya's largest city, and outside villages and cities throughout Africa, India and other parts of Southern Asia. Accordingly, Leopards could pose a threat in areas one might otherwise deem as safe. Leopards generally kill at night, and in urban areas may prey upon stray dogs and cats and also on rodents. An injured, old, or sick Leopard in these areas could pose a threat, but a healthy Leopard will do its best to remain unseen by humans. In India, partially cremated bodies may be responsible for habituating some Leopards into feeding on, first carcasses, and then living humans. One Leopard in India is reputed to have killed 200 people. Leopards are one of the smaller 'big cats,' and an adult male may weigh no more than 60kg (130lb), but that's big and heavy enough to pose a lethal danger to any human, especially a child.

Puma

Puma concolor

Until relatively recently, attacks upon humans by Mountain Lions, also more properly known as Pumas, were rare, with the majority of reports originating in British Columbia, Canada. In the last 20 years or so fatal attacks, while still quite rare, have increased and spread to other areas, and this is due to humans moving in and living and playing in what was once wild, Puma country. In the USA, joggers and cyclists in Colorado and in California have been fatally attacked, and it is often suspected that the victim, usually a runner or cyclist, triggered a flee-chase response in the predator. Most predators are taught to kill particular prey items by their mothers, and humans are not on the usual menu for a Puma. Sadly, as more people move into wild country, transforming what was formerly true wilderness into sprawling suburban estates where deer and elk now roam unmolested, Pumas may move in to capitalize on the now abundant prey and in the process they can get themselves in trouble. Accidents and tragedies will probably continue to occur, but don't blame the Puma – he didn't move into your neighbourhood, you moved into his!

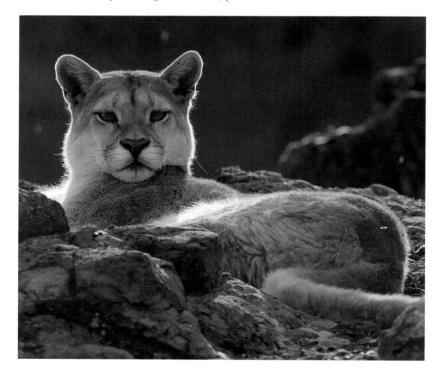

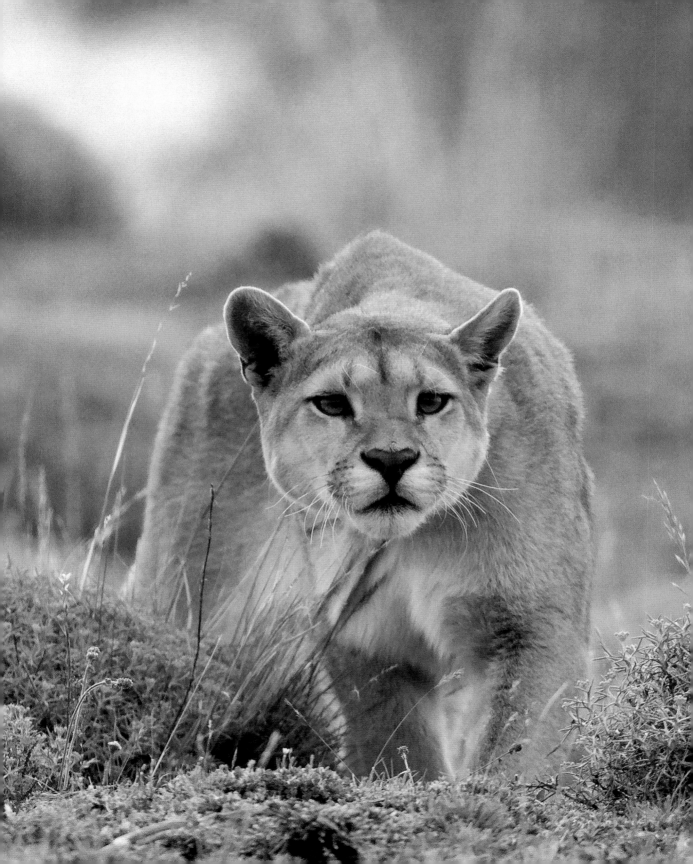

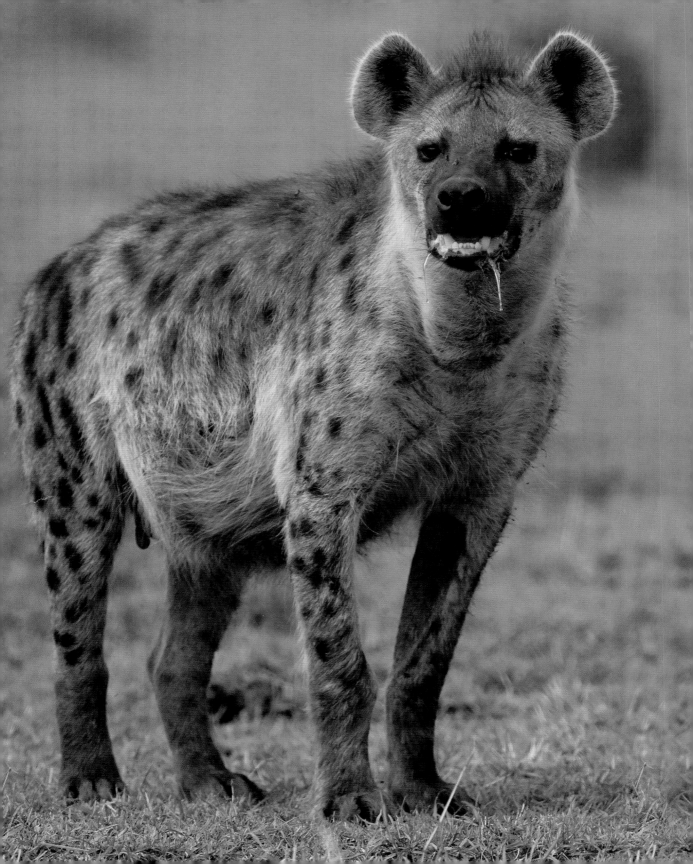

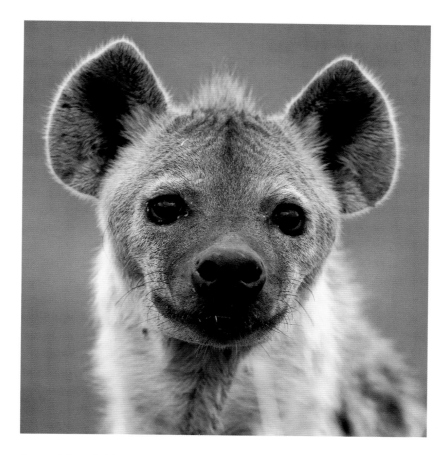

Spotted Hyena
Crocuta crocuta

Hyenas are often regarded as cowardly scavengers, but the Hyena, the second-largest carnivore in Africa, is a formidable predator capable of killing a Wildebeest or Zebra. Prior to 24-hour observations and nocturnal studies, Hyenas seen at dawn surrounding Lions at kills were mistakenly believed to be waiting to scavenge the remains. Later studies proved this false, revealing that Hyenas often made the kill, which was then stolen from them by a Lion pride, and the Hyenas were simply waiting to appropriate what was originally their kill! Hyenas hunt at night, and although humans are normally not on the menu, a Hyena clan surrounding an unfortunate person after dark would pose a serious risk. With incredible endurance and the strongest jaws of any mammalian predator, a Spotted Hyena at night could be a very deadly creature.

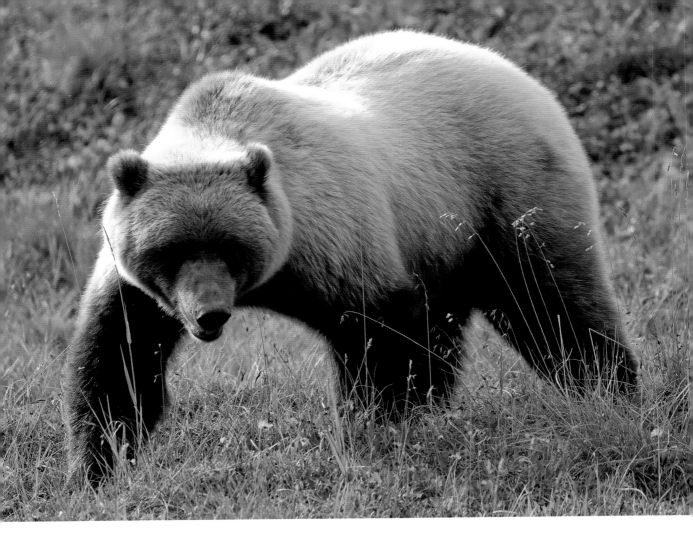

Grizzly Bear
Ursus arctos

Ever since the days of the Western explorers Meriwether Lewis and William Clark, the fearsome Grizzly Bear has been viewed with awe, respect and fear. Once ranging across much of the western United States and Canada, today this great Bear is restricted to only a few National Parks in the Lower 48, although it is still wide-ranging through western Canada and Alaska. They are dangerous, attacking, killing and eating hikers or campers who have disturbed a Grizzly Bear at its kill, triggered a defence response in a mother Bear with cubs, or simply annoyed a Bear by approaching too closely, often in the case of photographers more interested in a picture than their own safety. Like almost all the predators discussed in this book, Grizzlies do not actively hunt humans, but their large size, incredible strength and speed and short temper makes this one animal which human visitors into its territory should respect and treat with caution.

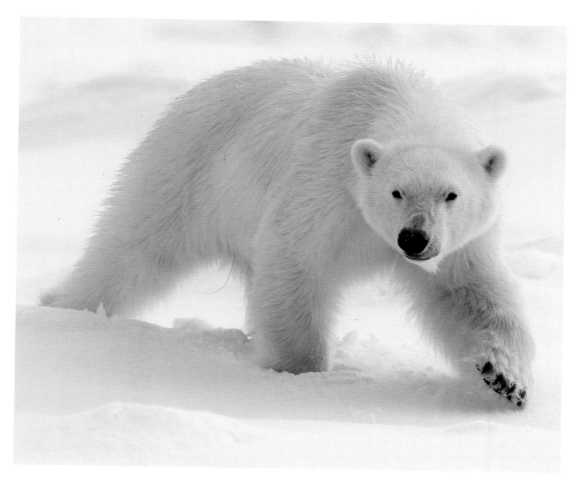

Polar Bear
Ursus maritimus

The natural habitat of the Polar Bear is a landscape where few humans wander. For much of the year, a Polar Bear may live on ice, following the scent of a seal or other prey for miles as it hunts. Polar Bears have no instinctive fear of humans and therefore may readily approach people, either drawn by curiosity or by hunger. Either way, an unwary human could end up as lunch. In Canada in the small town of Churchill, Manitoba, Polar Bears pass through each year as they begin their journey to return to the ice. Townspeople are vigilant during late October and early November, and problem bears that remain in or near the town are tranquilized and detained in a 'Bear Jail' until Hudson Bay freezes and the bears can be safely released to hunt their usual prey, the seal.

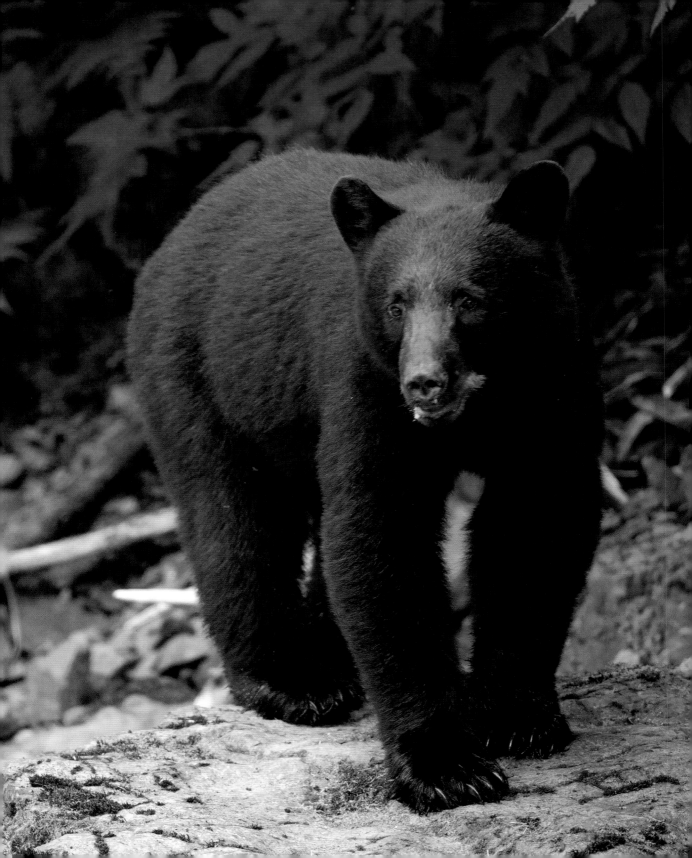

Black Bear
Ursus americanus

The most commonly seen Bear in North America is the Black Bear, and throughout most of its range this species is timid and retiring, although misguided people occasionally habituate one by feeding it handouts. The Black Bears of the Lower 48 states and eastern Canada are the descendants of Bears that successfully avoided humans, Bears that were not aggressive and confrontational. Belligerent Bears were likely to be shot. Accordingly, the theory goes that the survivors lack aggressive tendencies. That may be why Black Bears in Alaska and western Canada can be more dangerous and aggressive then their counterparts, as they have not had the same weeding out, selective pressure that the southern and eastern populations endured. While most Grizzly Bear attacks are generated by some degree of self-defence, most Black Bear attacks are thought to be for food. For Grizzlies, one is advised to play dead, endure the mauling, and survive while the 'Griz' makes its lesson clear. With Black Bears, the advice is to fight back, as it is likely that an attacking Black Bear has a meal on its mind. Alarmingly, in recent years some Black Bears in the eastern United States have attacked campers unprovoked, as if the fear of humans has been lost and the Bear now views people as a potential food source.

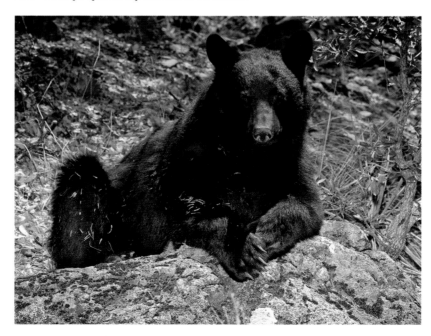

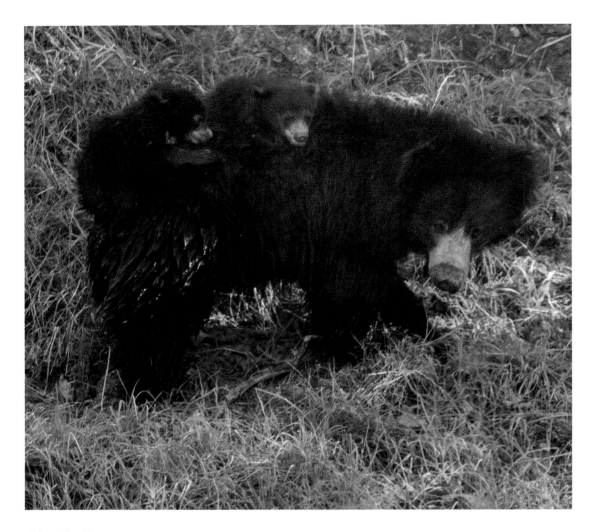

Sloth Bear
Melursus ursinus

Although primarily a termite- and ant-eater, Sloth Bears will eat meat, and these animals can be extremely unpredictable in their behaviour. Equipped with long, sharp claws and powerful forelimbs and shoulders, which can be used for digging a bear-sized hole into an ant-hill in minutes, and the usual sharp, long canine teeth of any predator, this dopey-looking, shambling Bear can be quite dangerous. Found in India and other parts of Southern Asia, Sloth Bears are often feared by foresters far more than Tigers, as a surprised Tiger is likely to run off, while a Bear may charge instead. One infamous Sloth Bear killed or severely mauled over 30 villagers in southern India in the 1950s.

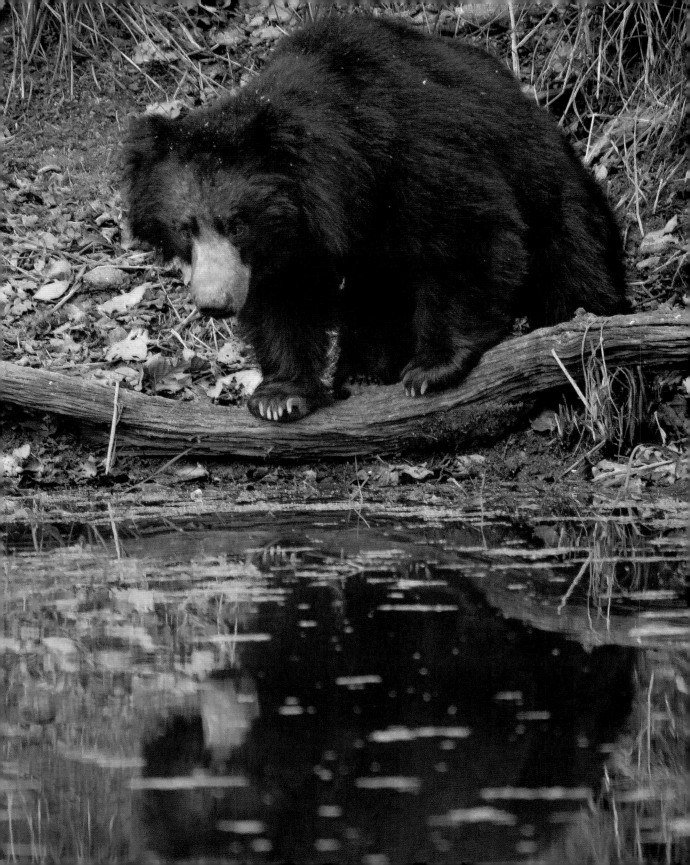

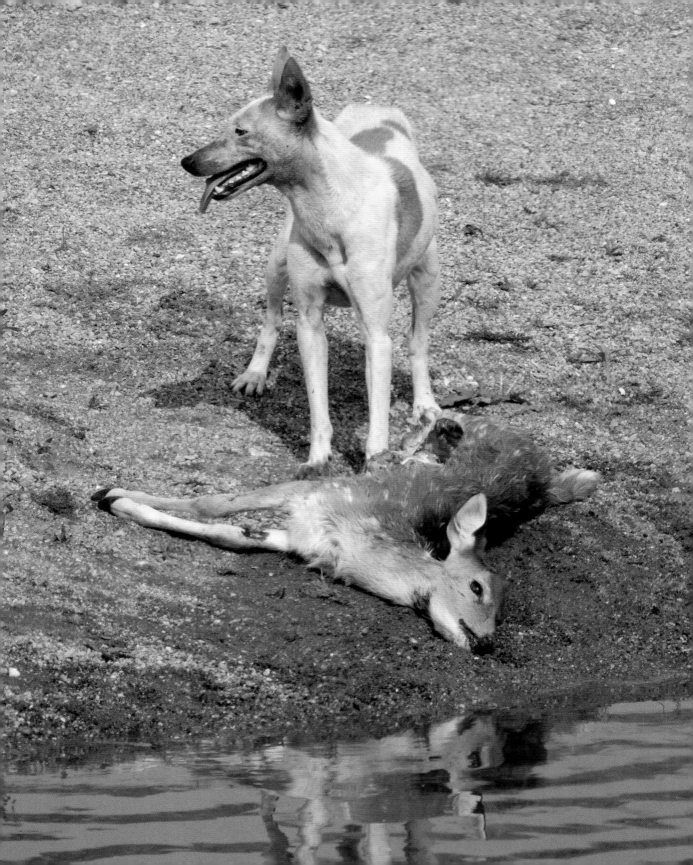

Domestic Feral Dog
Canis lupus familiaris

'Man's Best Friend' shouldn't pose a deadly threat to humans, but pet dogs may kill more people per year than any other mammal (excluding other humans, of course). In the United States there have been more than 300 fatal dog attacks in the past 20 years, and sometimes the level of human fatalities may reach over 30 per year. Domestic dogs trained to attack are especially dangerous, and specific varieties, like the Pit Bull, have been involved in the majority of incidents. One wouldn't think that domestic dogs in the wild could be a problem, but in some areas feral dogs, dogs now living without human assistance or care, roam fields and forests in packs. These dogs, which have now reverted to their wild state, may have no natural fear of humans and are perhaps among the most dangerous and deadly animals that you could come across.

Orca
Orcinus orca

The Orca, also known by its rather inaccurate name of 'Killer Whale,' is actually the largest of the Dolphin species, and generally innocuous and curious with regards to humans. There are accounts, which may simply be tall tales by sailors, of Orcas attacking small boats, but there are far more substantiated records of Orcas apparently actively helping humans, by alerting sailors that dangerous cliffs lay ahead. Orcas have earned the appellation 'Killer' since some populations or subspecies actively feed on the large Baleen Whales, subduing this much larger prey by repeated bites or by weighing them down and drowning exhausted, fleeing animals. In seaquariums, in an environment totally alien to a huge, free-roaming and intelligent mammal, some Orcas have turned on their trainers and drowned or fatally maimed their victims. In the wild, that behaviour has never been documented, making the Orca a deadly creature only when humans interfere by taking them into captivity.

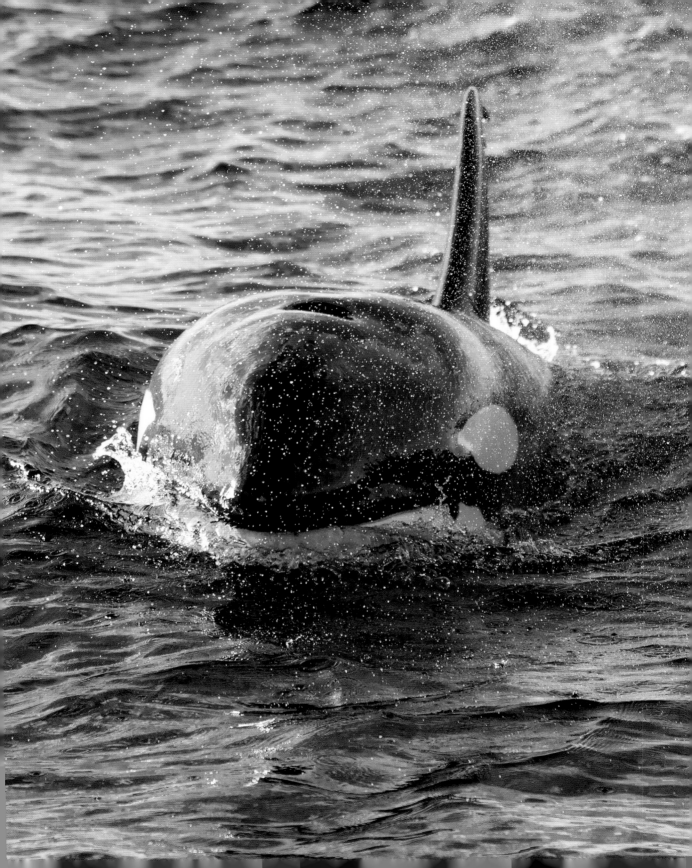

Rats
Rattus species

It is hard to believe that a little rodent weighing only 0.5kg (1lb) can be so deadly, but the genus *Rattus*, which includes the widespread and commonly seen Brown Rat, *Rattus norvegicus*, is a killer. Nearly a dozen human diseases are linked to Rats, transmitted by their fleas or by their droppings, especially around food storage areas. In the middle of the 1300s, perhaps as many as 200 million people died from Bubonic Plague, or 'Black Death,' which was transmitted via fleas that were carried by Black Rats, *Rattus rattus*. This death toll may have represented 60 per cent of Europe's entire human population, afflicting almost every country on the continent. Rats, via their fleas, can still transmit Bubonic Plague and Pneumonic Plague, with mortality rates of up to 90 per cent. Additionally, Rats damage food crops and food storage areas, fouling food stocks via their droppings.

Raccoon
Procyon lotor

The American 'masked bandit' is normally a harmless lower-level omnivore, becoming a nuisance or a pest only when it raids a garbage bin or destroys a bird feeder in a suburban garden. One wouldn't consider this attractive animal deadly nor need worry about a Raccoon unless one is kept as a pet. Orphaned Raccoons are occasionally taken in by well-meaning people and make cute and lively pets, although adults often turn nasty and unpredictable. However, that's not the issue. Raccoons can carry Rabies, one of the deadliest of all viruses. The frightening aspect of this is that a Raccoon can transmit rabies to a human via a lick or a scratch, infecting and killing the victim while the Raccoon lives on, not succumbing to the disease until months or years later.

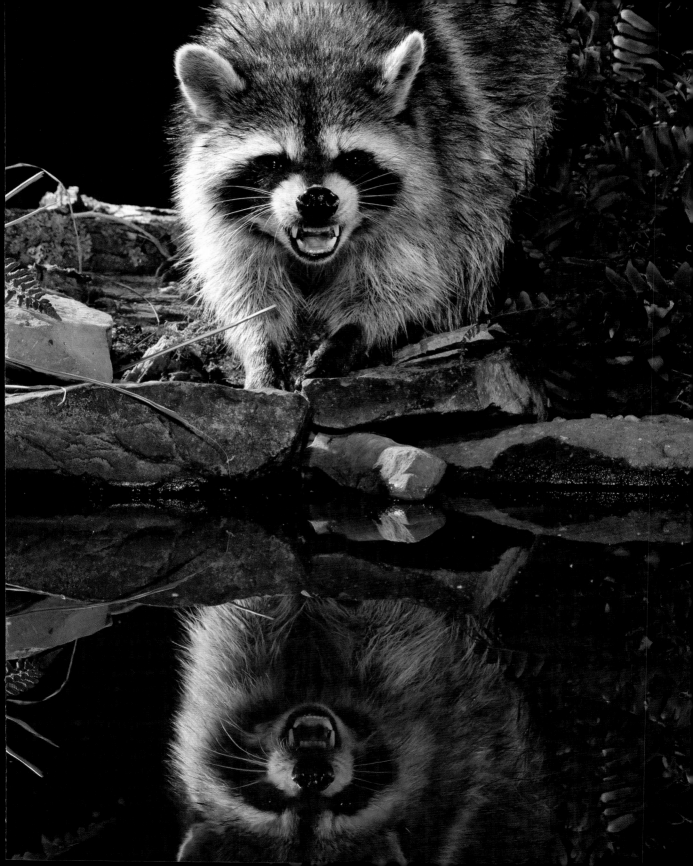

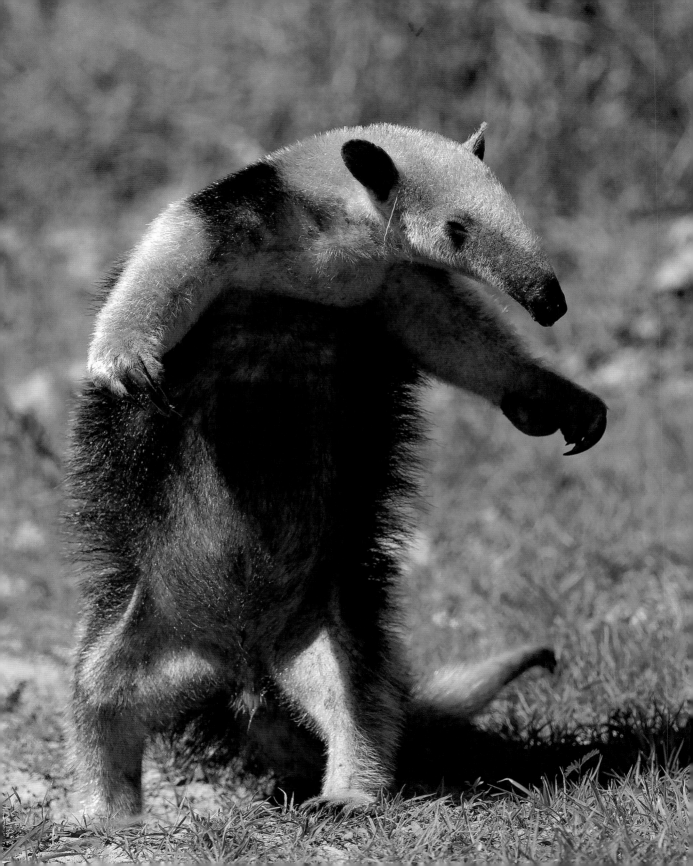

Giant Anteater
Myrmecophaga tridactyla

Tamanduas
Tamandua species

One would not think that the odd and ungainly looking Giant Anteater could be a threat to humans, but its long and sharp front claws can do terrible damage. These claws are normally used for tearing into rock-hard, cement-like termite mounds or for digging into the compacted, sun-baked soil of South American grasslands as the Anteater seeks out ants. Giant Anteaters are toothless, and have a tiny, tubular mouth, which is perfectly suited for the long, sticky tongue it uses for drawing in its insect prey. A cornered Giant Anteater, like its smaller cousins the Tamanduas (left), will rear up, standing on its hind-legs with forelimbs held wide, prepared to give a slashing blow. Anteaters are hunted for various reasons, including for meat and for leather, and in defending themselves they have seriously injured and killed hunters who came too close. The Anteater is reputed to be able to successfully ward off or kill Jaguars, grasping this predator between its forelegs and tearing with its claws.

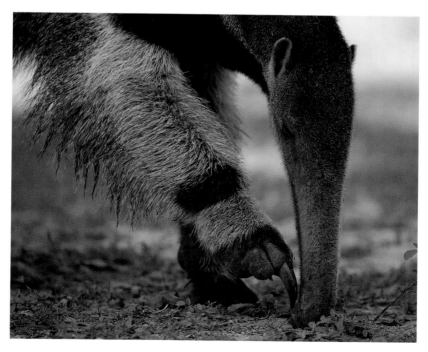

Bats
Order Chiroptera with more than 1,000 species

Bats are vital to the world's ecosystems, performing essential roles in pollinating plants or reducing populations of mosquitoes and other pesky insects. In North America, a devastating disease known as 'White Nose Syndrome' has decimated bat populations, in some areas by as much as 95 per cent. The skies at twilight, once marked by the darting silhouettes of feeding bats, are now empty, and lakeside resorts, formerly relatively free of mosquitoes, are now plagued by blood-thirsty insects. Unfortunately, Bats are the mammals most responsible for transmitting rabies, tainting the reputation of this valuable mammal as one to loathe. In North America an infected and sick Bat may bite someone unwise enough to pick it up, but in Central America and northern South America bats may actively seek out humans to bite. In doing so, infected Vampire Bats can transmit rabies when they bite and feed on a sleeping victim. Vampire Bat bites are virtually painless, as the Bat slices a small nick in the skin with razor-sharp canine teeth, while their saliva inhibits coagulation. Fortunately, less than 1 per cent of these Bats carry rabies. In other parts of the world, Asian and Australian Fruit Bat species carry Nipah virus and Hendra virus, and in central Africa Fruit Bats are suspected, but not proven, to be carriers of Ebola virus, all of which are deadly to humans in varying degrees.

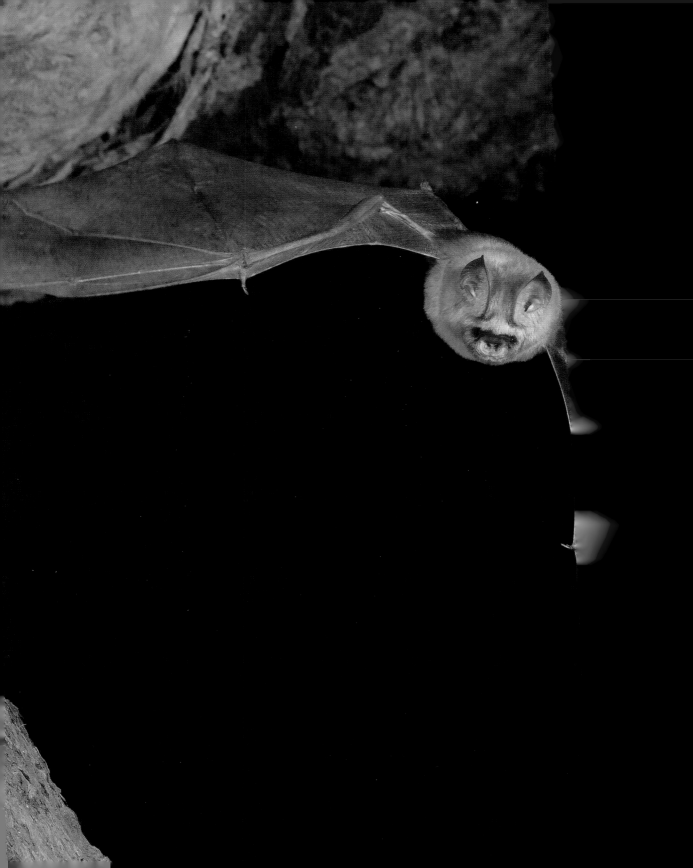

Platypus
Ornithorhynchus anatinus

The duck-billed Platypus is one of only five known poisonous or venomous mammals, and unlike the other four this mammal delivers its venom via a sharp spur located on its hind-leg rather than by biting, which is the usual method of delivering venom. The entire apparatus is for defence, and no human deaths have been recorded, although the venom is potent enough to kill domestic dogs and other small mammals. Accordingly, a small child, in the extremely unlikely event of encountering and handling a wild Platypus, could be killed by the only mammal capable of doing so by venom! This risk, of course, is almost non-existent, and this aquatic mammal is so reclusive that many people living in areas where it is found have never even see one.

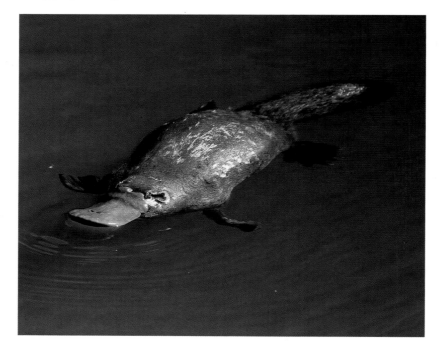

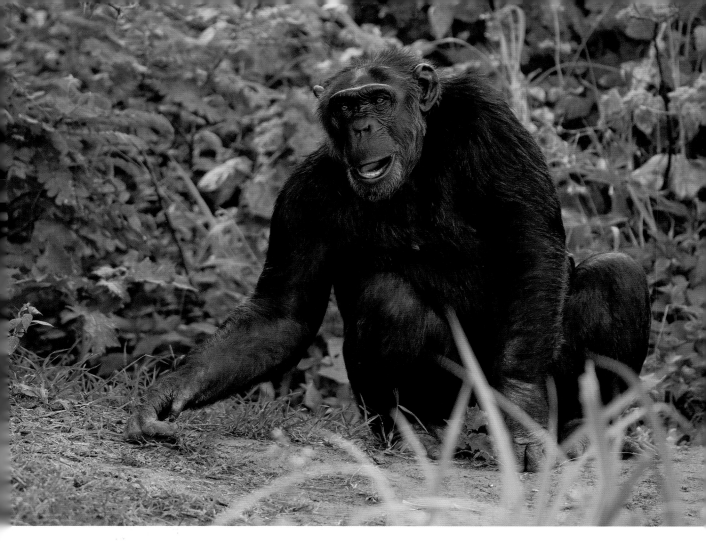

Chimpanzee
Pan troglodytes

In the wild our closest living relative, the Chimpanzee, poses no threat to human life. Chimpanzees are omnivorous, and although they are normally thought of as vegetarians, happily feeding upon leaves and fruits, they will hunt, kill and consume other primate species, displaying remarkable cooperation as they do so. Like so many other mammals, however, Chimpanzees in captivity are another matter, and a male weighing 70kg (150lb) that turns aggressive can be extremely dangerous to people. The Chimpanzee's strength is phenomenal, and an adult may be stronger than five men. No deaths have been recorded from a pet Chimpanzee, but several people have been nearly fatally injured by a pet that turned aggressive or by a captive that was lucky enough to grab hold of a passer-by. There is an even more deadly primate, however, one so deadly that we'll save that species until the very end of this book.

DEADLY BIRDS

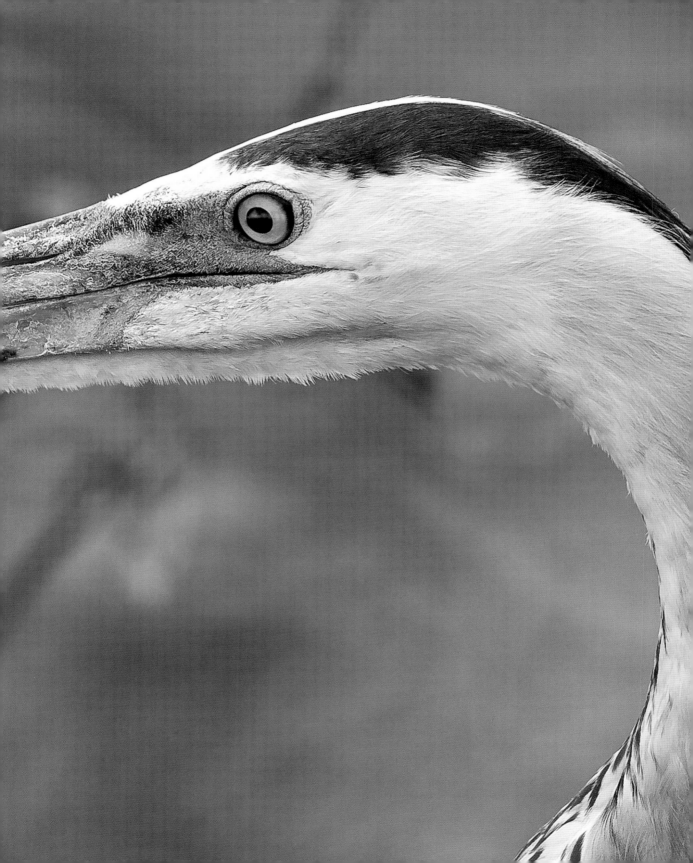

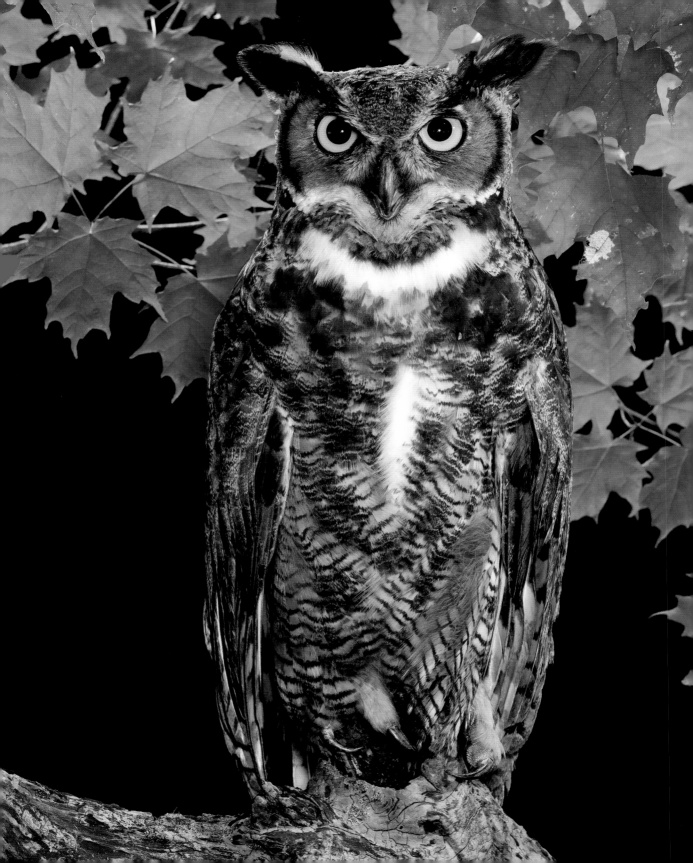

CHAPTER TWO
DEADLY BIRDS

Taxonomy, the classification of living things, is a fluid science, as new information and techniques impart fresh insight into the relationships and evolutionary history of plants and animals. At one time, the vertebrates, the animals with backbones, were divided into several basic groups, with Birds and Reptiles separated as two of those divisions, called a Class. Today, the extinct Dinosaurs, Birds, and Reptiles are all grouped together into one Class, and DNA analysis has resulted in the surprising fact that a bird is more closely related to a Crocodile than a Crocodile is to a similar-looking true Lizard! One could argue, then, that the rapacious Velociraptors of *Jurassic Park* fame were actually deadly birds!

The more recent discoveries in the fossil record have revealed that many species of Dinosaur were indeed covered in feathers or a feathery coating, just as the birds are today. Looking at an Ostrich, Rhea or Emu, it's not difficult to see the similarity to an ancient Ornithischian or Theropod Dinosaur, the major difference being that the present-day birds lack teeth. The feet are nearly identical, and the damage some of them are capable of doing is considerable.

There are few truly deadly birds, and none of those we'll talk about pose a threat to humans under normal circumstances. As it is with most species of animal, people are not on their menu, and to attack or kill a human simply for the sake of doing so poses risks for the attacker as well as the intended victim. Consequently, most animal attacks, and certainly those involving birds, are defensive in nature, as a bird defends its nest or young, or fights back when cornered or attacked. Herons and egrets, with their long, sabre-like bills that are normally used to spear their prey, could seriously harm and perhaps even kill a well-meaning person who finds an injured Heron and attempts to pick it up and carry it to safety. The Heron, in defending itself, might strike with a lightning-fast stab of its bill, and aiming for the eyes, as they often do, well … the results could be devastating.

Birds defending their nest can be quite aggressive, and a 3kg (6.6lb) Goose flying by and striking a person on the head with a bony wing-joint could knock the target to the ground. Once, in the Florida Everglades, I saw a Barred Owl drop a large, powerfully built man to his knees when the owl, swooping in from behind, clipped him on the top of his head with its feet. The man quickly recovered, standing and angrily looking around, fists clenched, as he searched for the person that had hit him from behind. It took a bit of persuasion to convince him that he had actually been struck by an Owl, which was now sitting calmly a few feet off the boardwalk! The Barred Owl, of course, was simply defending its nesting territory, as someone was playing a taped recording of its call nearby, and the bird was aggressively seeking that intruder.

Back in 1937 one of Europe's most renowned bird photographers, Eric Hosking, lost an eye when the Tawny Owl he was attempting to photograph flashed through the darkness and raked him with its talons. Sidewalks and paths along some city streets in the United States have been closed at dusk when small, 20cm (8in) tall Screech Owls have dive-bombed passers-by that were too close to the owls' nest. At night, in the woods beside my studio I've had this same species rocket passed my head in an aggressive swoop when I found myself suddenly in the owls' nesting territory. Knowing the damage that a talon can do, and not seeing the attacker, well, I can tell you, it is a bit unsettling.

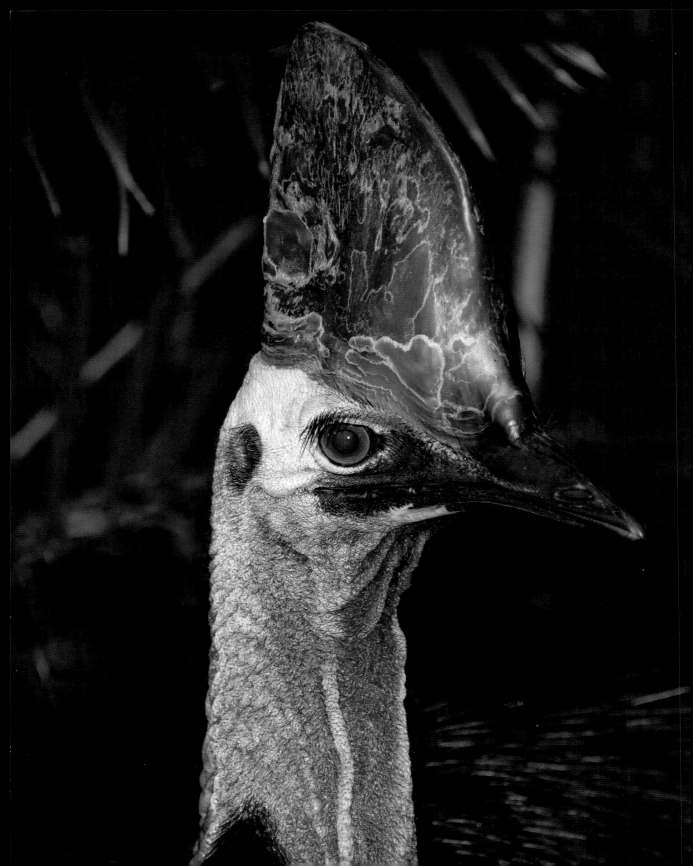

DEADLY BIRDS
THE SPECIES

Cassowaries
Casuarius species

If there is a bird that echoes the Velociraptors of the Jurassic it is the three species of Cassowary. Colourful and huge, sporting a bony crest and a red or purple head and neck, and standing as high as 2m (6.5ft), the Cassowaries truly are the living Dinosaurs. They are found in north-eastern Australia and in New Guinea including adjacent islands, haunting rainforests like dark shadows as they forage for fruits and small animals. Cassowaries have killed people, although only a couple of cases are known. Frank Buck, the near-legendary animal collector of the early 20th century, reported he had a worker killed by a Cassowary and in an unrelated incident a teenage boy was killed around roughly the same period of time. The boy was trying to kill the bird with a club, slipped, and the Cassowary kicked the boy in defence. The middle toe of this three-toed bird is dagger-like, much like the infamous Velociraptor, and it is used in defence when the bird kicks out with its enormously powerful legs.

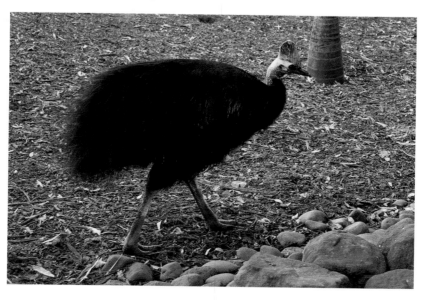

Ostrich
Struthio camelus

Common sense would dictate that humans should show deference and respect for a bird that can stand nearly 3m (9.8ft) tall and weigh nearly 150kg (330lb). Like the Cassowaries, Ostriches have a powerful foot with a long, sharp claw that can easily inflict a fatal wound. Ostriches are raised on farms for their feathers and meat, and handling this bird as stock can be very dangerous. In South Africa, two or three serious injuries or deaths occur nearly every year in and around these farms. In the wild, an Ostrich could be dangerously aggressive in defence of its nest or chicks, although this would be a more likely occurrence in a captive situation.

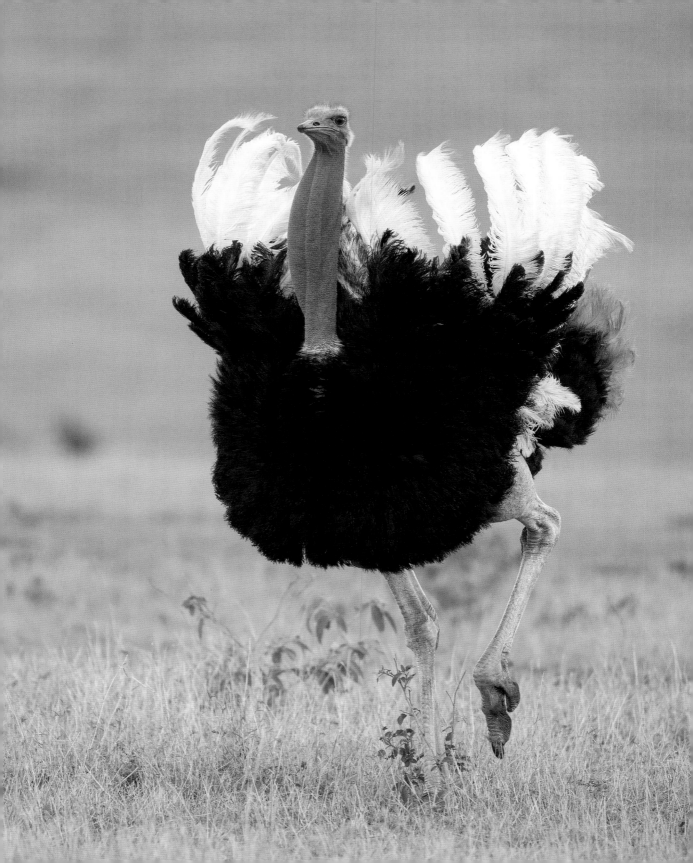

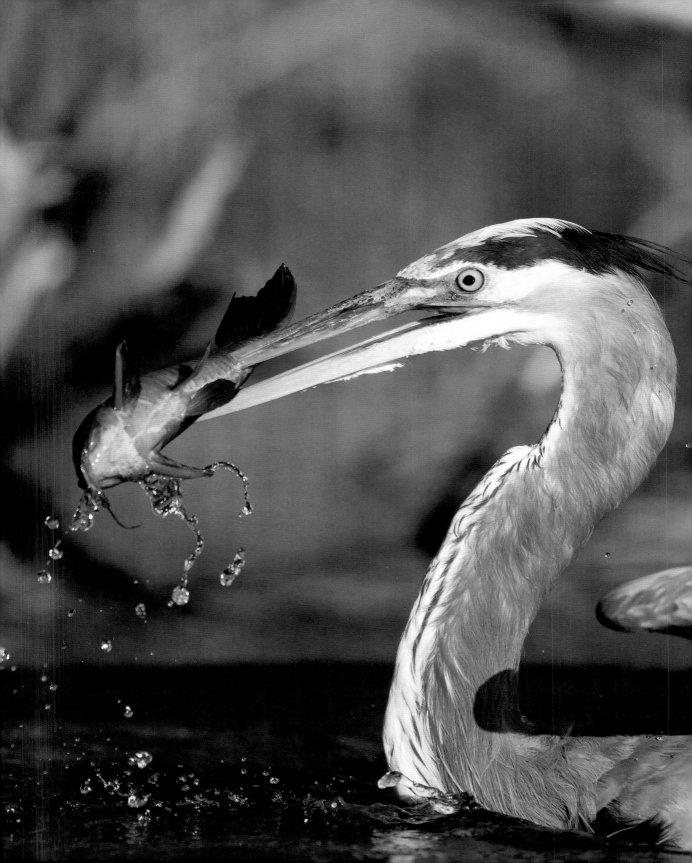

Great Blue Heron
Ardea herodias

No one should ever be hurt or injured by a Great Blue Heron, or by any of the many other large or small Heron and Egret species which are found on six of the seven continents. However, an injured Heron could be extremely dangerous, even deadly, if approached by someone intending to do the bird further harm or simply hoping to rescue the bird. The bird's bill is long and sharp and is normally used to spear their prey, sometimes running a powerful bill clean through a large eel or thick-bodied fish. That bill is also a potentially lethal weapon, and powered by a long neck, it can be stabbed forward in an instant and could seriously injure and perhaps even kill anyone who attempts to pick it up and carry it to safety. Caution must always be taken when attempting to handle or rescue any bird with a formidable bill, be that a Crow, Heron, Gannet or Pelican, as the bird is quite likely to strike out in defence, often aiming for the face and eyes.

Great Horned Owl
Bubo virginianus

Aside from species such as Screech Owls, which will occasionally dive-bomb people walking past a nest at night, Owls do not attack people unless their nest is actively threatened. In that situation, Great Horned Owls and other large Owl species, as well as many of the diurnal Birds of Prey may attack, striking out and raking the intruder with their talons. Northern Goshawks, one of the larger forest hawks, can be particularly aggressive, seemingly coming from nowhere to give an intruder a powerful blow. Bird banders, climbing trees to ring or band nestlings, regularly wear safety helmets for protection, and an Owl, Hawk, or Eagle could, presumably, knock someone with enough force to disorient the intruder, perhaps precipitating a fatal fall from a tree or cliff ledge.

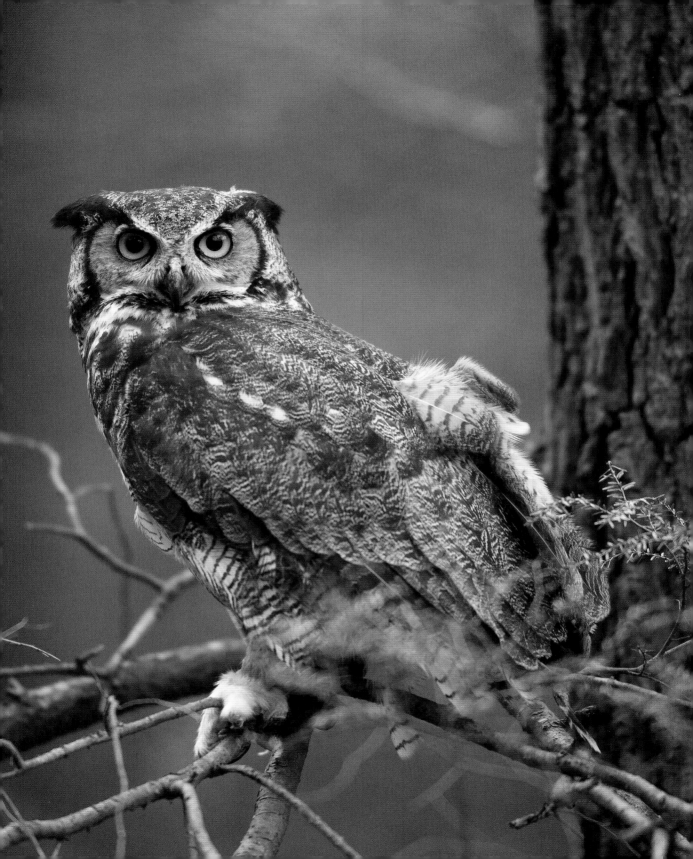

DEADLY REPTILES
AND AMPHIBIANS

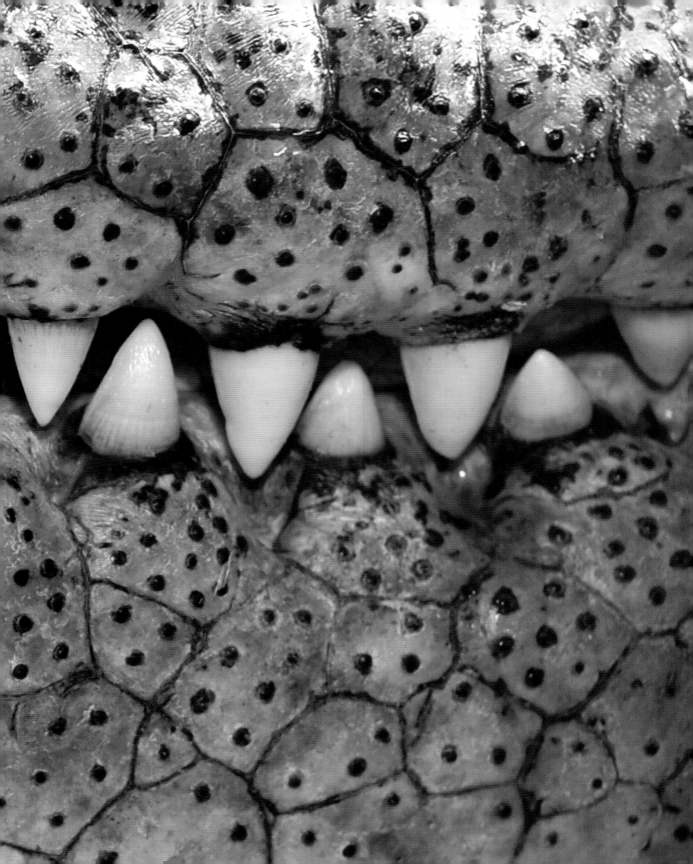

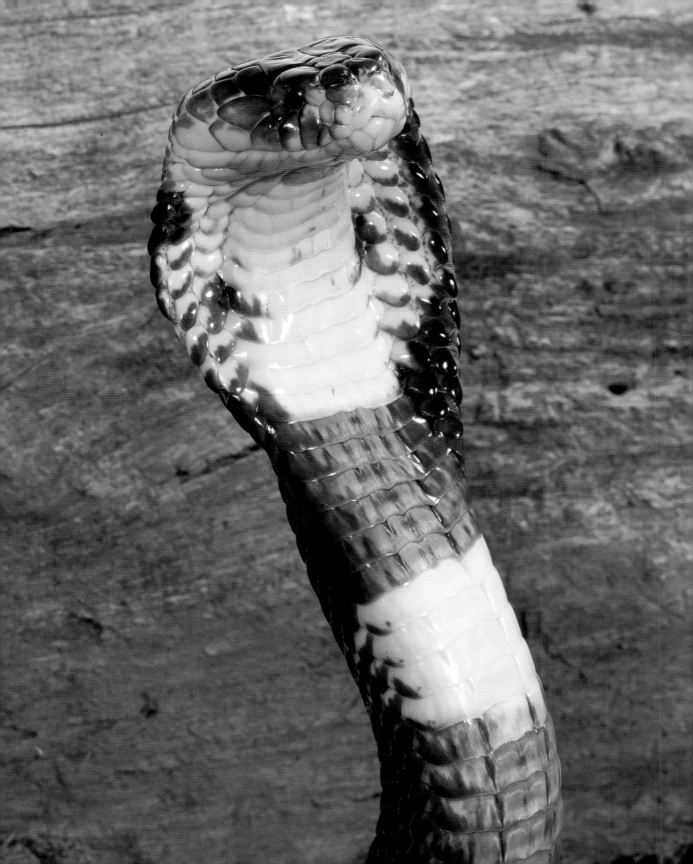

CHAPTER THREE
DEADLY REPTILES AND AMPHIBIANS

Amber, unblinking eyes watched the shoreline, as they had for the last several days, observing a pattern that was followed daily. In late afternoon the prey item the hunter had been studying once more stepped down towards the shoreline and the hunter sank slowly beneath the water's surface. The powerful lateral swings of the animal's tail propelled it forward rapidly, until, just feet from the shoreline the predator stopped and quietly, slowly surfaced, revealing only a small portion of its nearly 1m (3.3ft) long snout. The intended prey, a woman, her large water bucket nearly filled, was too busy scooping in the last cups of muddy river water and failed to notice the shape that slowly inched closer. Then, with a powerful lunge propelled by the long, flat-sided tail, the massive creature lurched from the water in a blinding spray, grabbing the startled woman by an arm and, nearly as quickly, pulling her back into and beneath the water as the Crocodile and its prey disappeared.

Somewhere in Central, Eastern and Southern Africa, in India and Southeast Asia, or on any number of islands in Indonesia, a scene like this occurs nearly daily. An estimated 1,000 or more people are killed by Crocodiles every year, making these formidable reptiles the most deadly true predator of humans. Unlike Tigers, Lions or Leopards, which may turn to man-eating when the big cat grows old, becomes injured or its natural prey is scarce, Crocodiles hunt people because they can.

For humans, the Reptiles are truly among the world's most deadly creatures. Various Crocodiles regularly, and American Alligators and Black Caimans occasionally, take or attempt to prey on people. Rarely, a large Python takes a human for a meal, although many of the reports of this turn out to be hoaxes. More devastating, however, are the incidents that have nothing to do with food, but are merely accidents involving the reptile's deadly self-defence mechanism. Estimates vary, but at least 90,000 people are killed each year by venomous snakes, confirming the Reptiles as the most deadly group of vertebrates.

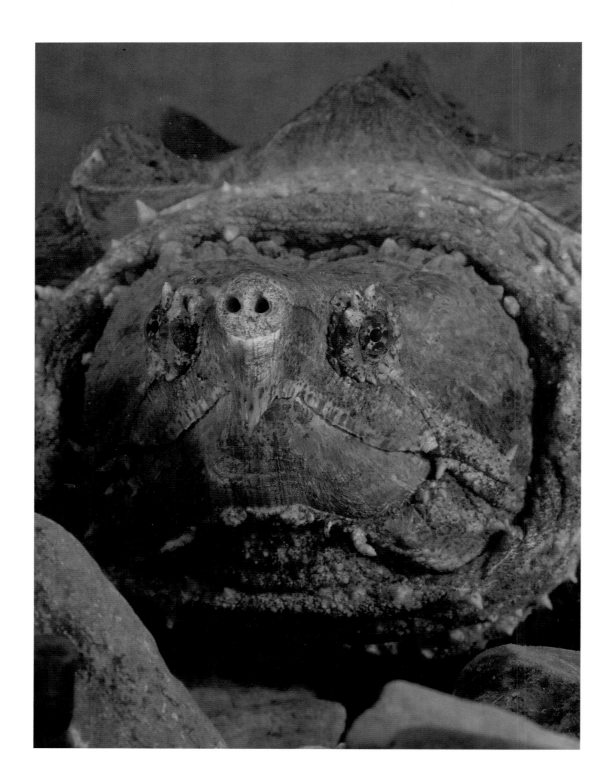

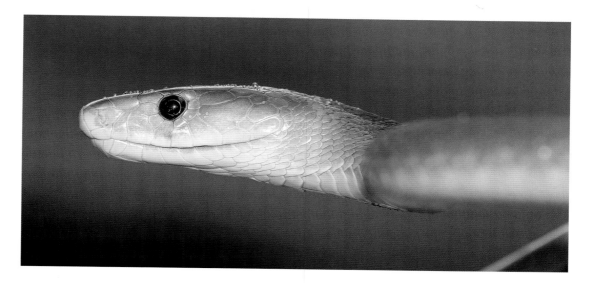

Many snake bites occur when an unlucky victim steps upon a snake or places a hand on a ledge, log or tree limb where a snake is resting. The snake, alarmed or in pain, bites or strikes in self-defence. Most of these bites, and there may be nearly two million each year, occur in tropical and subtropical countries, where people often walk barefoot and do manual labour in fields where stepping or reaching in to a bush or clump of vegetation could result in a deadly encounter. In contrast, in the United States the vast majority of bites are practically self-induced, as the victim, often a young man, tries to catch, handle or kill a venomous snake. In India, where as many as 200,000 people are bitten each year, I've watched with much amazement as hundreds, perhaps thousands of people walked at dusk or later along the berm of rural roads without flashlights or torches. From personal experience I know how difficult it can be to see any snake lying in a bush or patch of grass, and I could only imagine how easy it would be for some unlucky soul to step upon a snake. Although less than 10 per cent of these bites may prove fatal, survivors may be maimed or crippled for life.

The effect and the potency of a venomous snake bite vary, depending upon the exact composition of the venom involved. Typically, venom is divided into three groups; haemotoxic, neurotoxic and cytotoxic, where blood, nerves or cells are most affected. The venom of some species have a mixture of all three, and strangely enough, some populations of a particular species incorporate a mixture of haemotoxic and neurotoxic venoms while other populations, in a different locale, only have one type of venom. Tissue damage is common with some bites, and survivors may end up having a limb amputated from the necrosis as the venom literally dissolves the tissue in the surrounding area. I've seen horrific images of legs, where a foot and a knee seemed normal and intact, but between the two there was nothing but bloody bone. It's enough to make a snake-lover very careful around snakes!

Although snake venom is usually delivered through a bite, some Cobras have the unusual ability to actually spit venom towards the face and eyes of a potential predator. Specially constructed fangs, with forward-facing grooves that act as a sort of nozzle, allow the Cobra to spit with accuracy

from a distance of 2m (6.5ft) or more. I know, for I've been on the receiving end of a spitting Cobra, catching some venom in my eyes.

We were on safari, and when we found a Black Spitting Cobra I had my driver, against his strenuous objections, cross in front of the Cobra's path. As my driver feared, the snake took that obstruction as a place to hide, and crawled into the wheel well of our Land Rover. Try as we might, we could not get the snake out of its hiding place and eventually we drove on, finally ending our game drive back at our safari lodge where I was sure the snake would be killed as soon as it showed itself. So Mary Ann and I decided to rescue the snake.

I had the camp staff make some crude snake hooks, and one of our drivers climbed inside the vehicle, with all the windows securely closed, and pounded on the floor of the vehicle with a rock. I hoped that would disturb the snake sufficiently for me to get a hook around it, and sure enough, it worked, and I eventually pulled out the 2m (6.5ft) long snake, clearing it from the vehicle. The Cobra immediately reared and faced me, and my driver yelled that it was going to spit, and it did. I was wearing my eye glasses, which could have afforded some protection but in the effort involved in securing the snake I had sweated, and my glasses had slipped far down my nose. The venom, or a part of it, hit me, and a moment later the snake spat again, and I received another dose.

Strangely the pain wasn't as bad as I had expected, but as the venom took effect a veil of brown seemed to descend across my vision, like a graduated tobacco filter that I've used in my photography. I yelled for some water to rinse my eye, while Mary Ann, now under a lot of stress, continued in our efforts to capture the snake. I rinsed my eye with water, and then with milk, and between Mary Ann and me, we eventually boxed the snake. Mary Ann and our driver released the snake far from camp, after first dropping me off at

a Maasai health clinic. Although I later suffered a fairly serious eye infection I did not experience any lasting damage, which could have resulted in severe cornea ulcerations or even blindness.

My first love in the Natural History world was reptiles, and I've dealt with venomous snakes for most of my life. However, I've always handled a venomous snake with snake hooks or tongs, never with my bare hands, which is a near-certain way to eventually be bitten. I mentioned earlier that in the United States the majority of venomous snake bites occur because the victim was purposefully interacting with the snake. Sometimes the person is bitten when he or she picks up a 'dead' snake they had just 'killed,' but the reflexes of a dying snake still resulted in a bite. Others try catching snakes, foolishly pinning the snake's head down with a forked stick or an angle iron, and are bitten when they lift the stick or pole. Hobbyists and snake enthusiasts who keep venomous snakes have accidents in a variety of ways, many of which result in a snake bite.

In most developed countries venomous snake bites are rarely fatal, provided the victim gets to medical attention in time. Antivenom, which is often quite species-specific, counteracts the effect of a bite, but the treatment is expensive. In the United States, a person taking a 'selfie' while holding a Rattlesnake racked up a medical bill of over US$100,000, as the treatment for his bite required several shots of the expensive antivenom. In undeveloped countries, and for a certain few species of venomous snake, even this expensive treatment is not an option, and the victim suffers the consequences.

It has to be said, however, that the venom of all venomous snakes evolved either for defence, as in the case of Spitting Cobras, or for helping to capture prey. Unfortunately, that venom, and the apparatus to deliver a deadly brew, can injure or kill humans, making snakes, a vital part of Nature's ecosystems, a maligned and persecuted group.

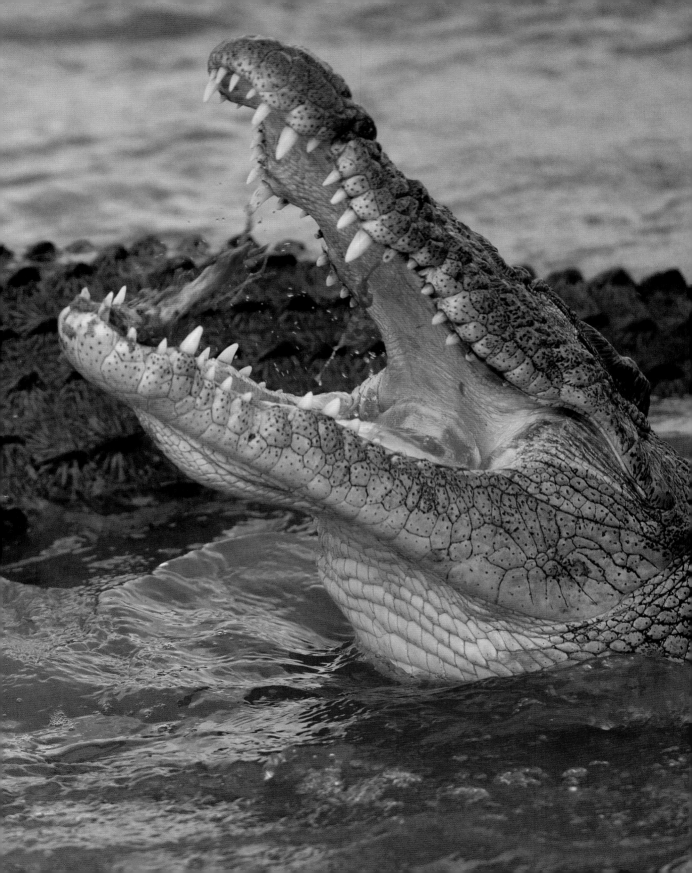

THE SPECIES

Nile Crocodile
Crocodylus niloticus

One could argue that the Nile Crocodile, found throughout much of Africa south of the Sahara, is Africa's greatest predator. Nile Crocodiles seemingly will tackle just about anything, having grabbed hold of African Elephant trunks, Giraffe snouts, young Hippopotamuses, African Lions and virtually anything else that wanders close to the water's edge or swims across a river or lake inhabited by this ultimate opportunistic predator. Of course, a Nile Crocodile might find itself going airborne after snapping onto an Elephant or a Giraffe! Humans are on the Nile Crocodile's menu as well. Along one river in Kenya in the 1960s it was estimated that Crocs killed at least 100 people per year. According to CrocBite, a worldwide database that tracks crocodilian attacks, at least 320 people were killed by Nile Crocodiles in a seven-year period ending in 2013. However, because of sketchy reporting the actual number killed was probably even higher.

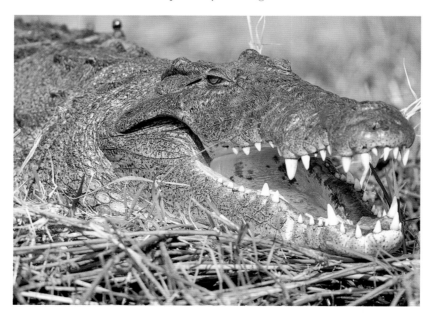

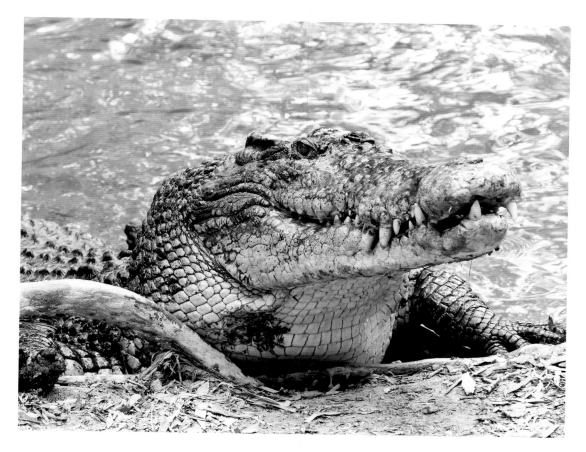

Saltwater Crocodile
Crocodylus porosus

Saltwater Crocodiles are the largest of all crocodiles, and indeed are the largest land- and river-dwelling predator in the world. The record length exceeds 6m (19.7ft) and the record weight over 1,300kg (1.4 tons), while an average adult male Saltwater Crocodile in Australia is about 5m (16ft) long and weighs nearly 1,000kg (1.1 tons). In contrast, the largest Polar Bear ever recorded weighed just over 1,000kg, and that was 200–300kg more than the average bear! Saltwater Crocodiles also have the most powerful jaws of any animal, with a bite force capable of crushing a cow's skull. Like the Nile Crocodile, Saltwater Crocs will prey upon anything they can catch, and that of course includes humans. In Australia, two people on average are killed each year by Crocs, and that low number is attributed to 'No Swimming' signs posted wherever Crocs are found. In other parts of their range, which extends from the eastern shores of India through Indonesia and New Guinea, deaths caused by Crocodiles are less likely to be reported and the number of human victims may even exceed that of the Nile Crocodile.

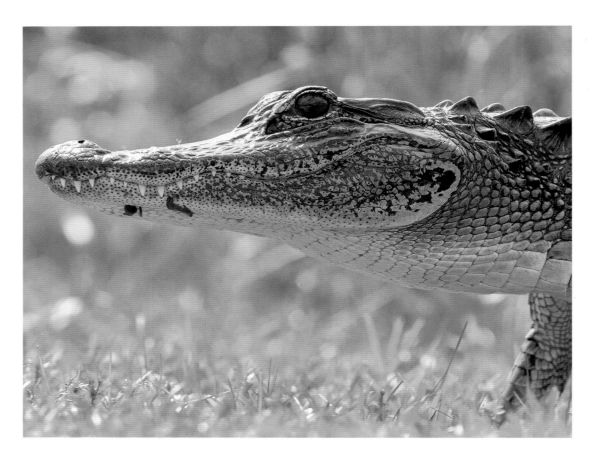

American Alligator
Alligator mississipiensis

Fifty years ago the American Alligator was threatened with extinction. Habitat loss, hunting and poaching had reduced populations of this large crocodilian throughout its range. The Alligator was subsequently granted protection and the population soon rebounded, as females may lay 50 eggs at a time. 'Gators are a common sight throughout southern Florida, and in many swamps, lakes and bayous throughout the southern United States, and unfortunately many people dismiss the potential danger of a large Alligator. Deadly attacks have occurred when clueless daredevils swam in known 'Gator waters at night, when the advantage clearly lies with the Alligator. In the Amazon Basin, a related species, the Black Caiman, grows nearly as long, and this species takes at least one person every year, usually someone who is swimming or wading in their waters.

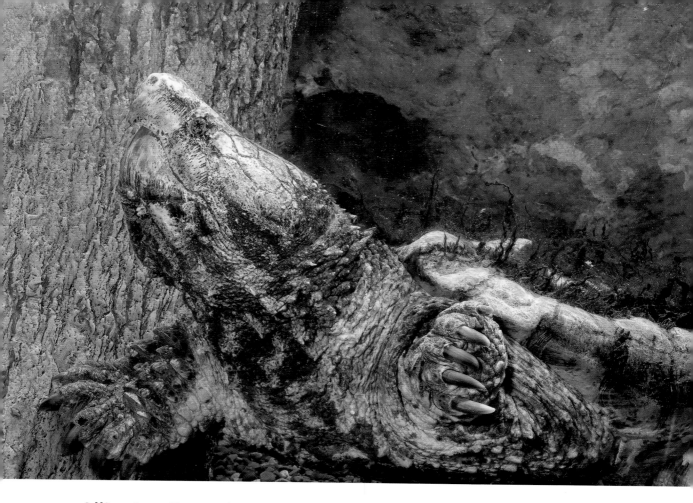

Alligator Snapping Turtle
Macrochelys temminckii

There are no records of anyone ever being killed by a turtle but if one has the potential to do so, it is this freshwater species. Alligator Snapping Turtles are huge and heavy, with a massive head and thick limbs sticking clear of a shell that can exceed 0.7m (2.3ft) in length. There are several records of specimens weighing over 100kg (220lb), and one was reputed to have topped the scales at over 180kg (400lb). Snapping Turtles get their name because of their snapping jaws, although the Common Snapping Turtle has the more irascible temper that probably gave this group its name. In the southern United States, some adventurous outdoorsmen go 'noodling,' where they wade in waist-deep water and reach under logs or into catfish burrows, catching fish with their bare hands. Poking an Alligator Snapping Turtle by mistake could easily cost someone their fingers, and if the fisherman was underwater at the time, and unable to surface because a Snapping Turtle was anchored in place inside a burrow, the encounter could prove fatal.

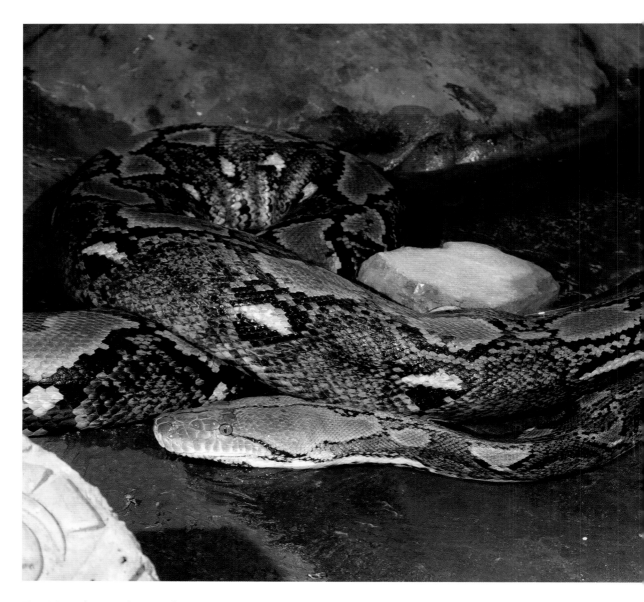

Reticulated Python
Python reticulatus

The Reticulated Python, so named because of the skin's net-like pattern, is the longest snake in the world. All Pythons and Boas are constrictors, meaning that they wrap around and squeeze their prey, and in doing so eventually suffocate it by compression of the chest cavity. While the odd leg or arm bone may be broken in this process, Pythons are not 'bone-crushers' in any way.

Reticulated Pythons often grow over 6m (20ft) long, and the record accepted length is 7.6m (25ft). There are several records of Reticulated Pythons killing and eating a person, although the broad shoulders or hips of an adult human would make swallowing one nearly impossible. Smaller statured teenagers and children are a different matter, but fatal attacks are indeed quite rare. While posing a slim threat to human welfare, a Reticulated Python living in the vicinity of a rural village probably performs far more good than the risk of harm, as a Python, particularly a young one, will avidly feed upon pesky rats.

Green Anaconda
Eunectes murinus

This is the world's heaviest snake, and a large adult may weigh twice as much as a Reticulated Python of the same length, although Anacondas rarely grow as long as the Python, with one of 5m (16ft) considered a long individual. Living in the Orinoco and Amazon River basins, as well as in the llanos of Venezuela and on several off-shore islands of South America, it is quite likely that a large Anaconda has, in the past, taken a child that was swimming or wading along a river's edge, but there are no confirmed records. Green Anacondas are frequently seen in the pet trade, and their large size and weight could make them a very dangerous pet should one be handled incautiously.

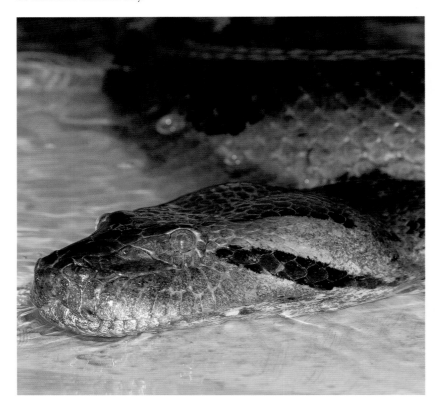

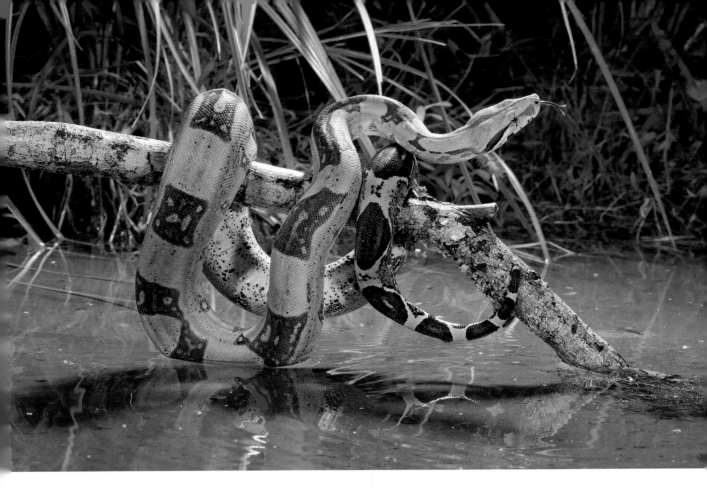

Boa Constrictor
Boa constrictor, and other pet constrictors

Boa Constrictors, Burmese Pythons and several other species of Boa and Python are frequently kept as pets by reptile enthusiasts. While the temperament of pet snakes varies, with some docile to a fault and others uncharacteristically bad-tempered and aggressive, many of these species grow to dangerous lengths. Boa Constrictors and Burmese Pythons, both commonly kept as pets, have record lengths of nearly 6m (20ft), and snake-handlers agree that any snake approaching 3m (10ft) in length is capable of killing its handler. Since Boas and Pythons kill by constriction, a large specimen could wrap around one's neck while being handled and begin squeezing, unintentionally suffocating the handler as a large, coiled snake is quite difficult to remove alone. A dancer performing in Southern Asia nearly died on stage when her Python did just that, while the audience looked on, believing that it was a part of the act. Fortunately someone recognized the danger and removed the snake before she was killed. Pet Pythons, either free-roaming in a home or having escaped from their cage, have strangled babies, and escaped Pythons in Florida regularly prey upon stray cats and dogs, and pose at least some threat to very small unattended children.

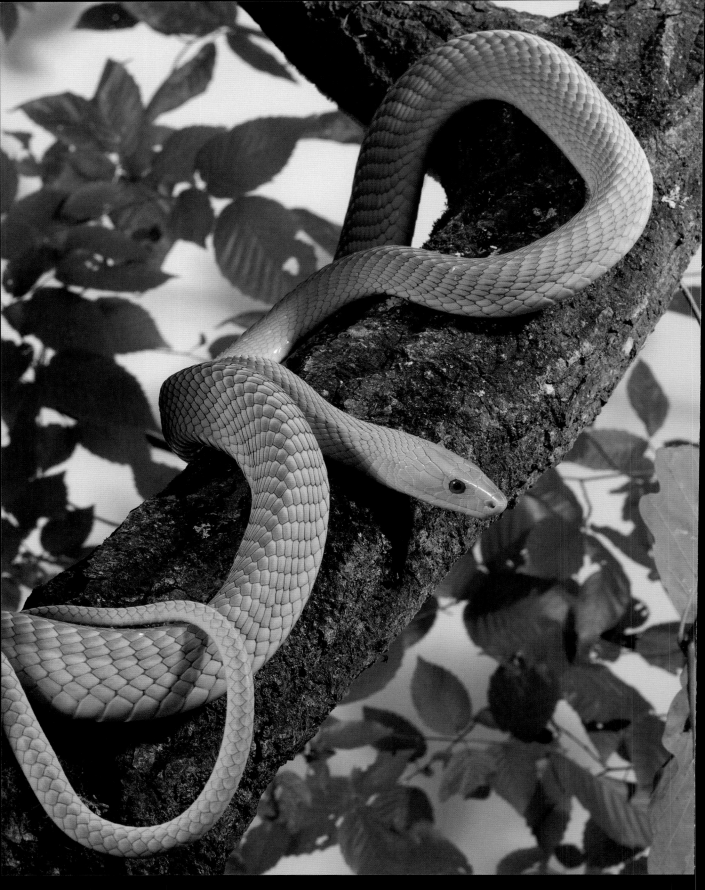

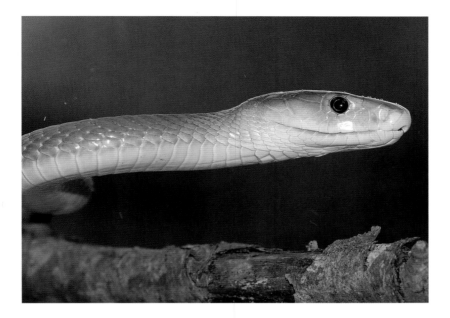

Green Mamba
Dendroaspis angusticeps

Black Mamba
D. polylepis

The name Mamba seems synonymous with death and danger for impressionable safari-goers in East Africa, and stories are often told of angry Mambas entering a vehicle, biting and killing everyone inside. Great campfire tales, to be sure, although with little truth, but that said, the Mambas are deadly snakes. Mambas are slender, long-bodied snakes, with the Black Mamba often growing to over 4m (13ft) in length. Green Mambas get their name from their skin colour, but the Black Mamba is usually grey or olive-coloured, and this large snake gets its name from the black interior of its mouth. When agitated or in a defensive display a Black Mamba will gape, revealing that frightening black interior. Mambas of both species can deliver a deadly bite, and prior to the use of antivenom bites from a Black Mamba were usually fatal. Death in some cases occurred in 30–45 minutes, although most doomed victims survived for 7–15 hours, usually succumbing to respiratory failure from paralysis of the muscles.

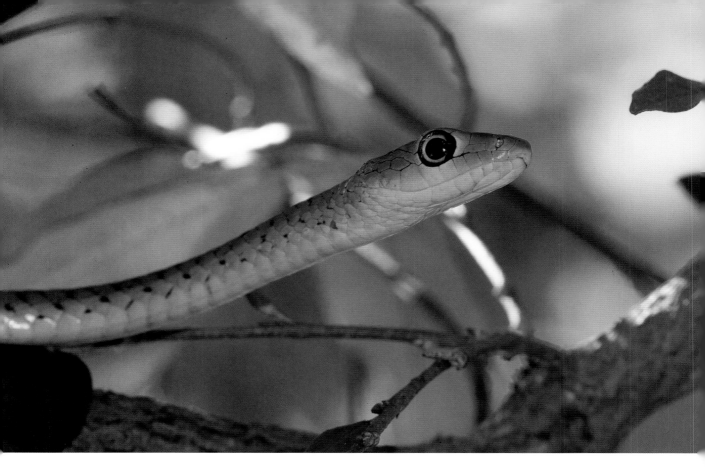

Boomslang
Dispholidus typus

It seems unlikely that an arboreal snake with Chameleons comprising a large part of its diet could be so deadly, but the Boomslang has a very lethal bite. While most venomous snakes have fangs in the front of their jaw, either fixed, as with Cobras and Kraits, or retractable, as with the Vipers and Pit-Vipers, Boomslangs are rear-fanged, with relatively small fangs located towards the back of their jaws. There are many different rear-fanged species, but only a few are potentially lethal, and the Boomslang is the most dangerous.

In 1957 one of the United States' most prominent herpetologists, Karl Patterson Schmidt, was examining a small Boomslang when it bit him. Although the deadliness of this snake may have been common knowledge among the residents of Africa, American scientists were unaware of the snake's toxicity and the victim viewed the bite as an opportunity to record the effect of a Boomslang's venom. That small snake created fatal haemorrhages, and in less than 24 hours he was dead.

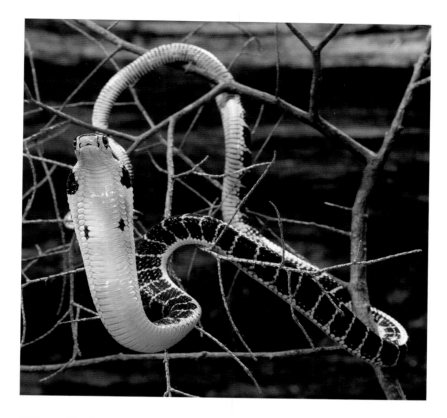

King Cobra
Ophiophagus hannah

Imagine walking down a bamboo-lined trail in South-East Asia. An overhanging limb bars your way and you duck down to pass beneath, and upon straightening upright once more you stand face-to-face with a snake that is rearing up and meeting your gaze at a height of nearly 2m (6.5ft)! That nightmarish scenario is possible should you meet a King Cobra, the world's longest snake. King Cobras have reached nearly 6m (20ft) in total length, and this snake does indeed often rear upright to one-third of its body length when it is disturbed. Unlike nearly all other snakes, King Cobra females actually construct a nest mound composed of fallen leaves and mulch where the female will remain in or around until her clutch of 20–40 eggs hatch. Normally an unaggressive snake, as all snakes usually are, King Cobra females will actively defend their nests. Bites from King Cobras are rare, but the amount of venom delivered by a large snake can be huge, nearly half a gram in a large dose and it is said that Indian Elephants have died within hours from a King Cobra bite.

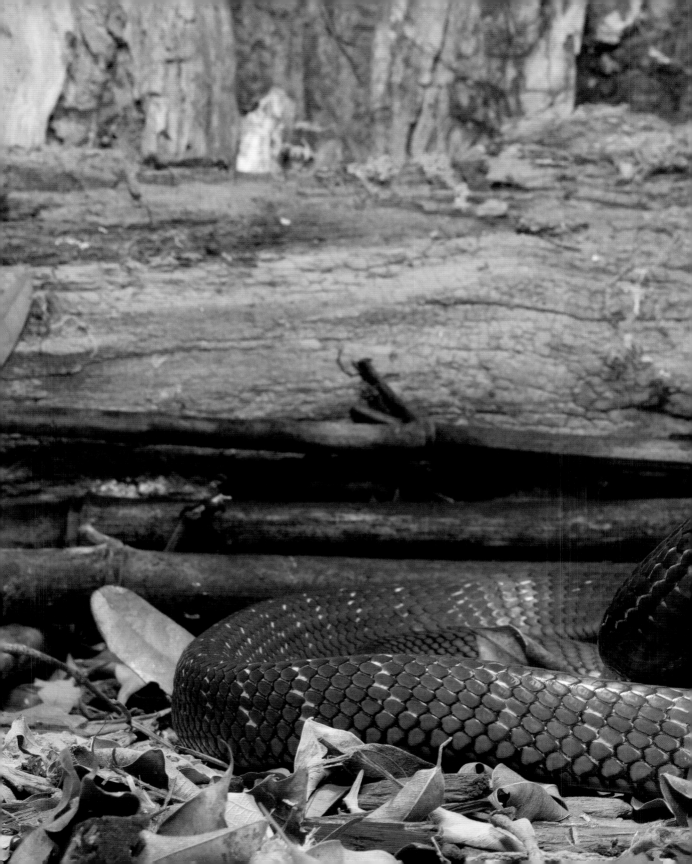

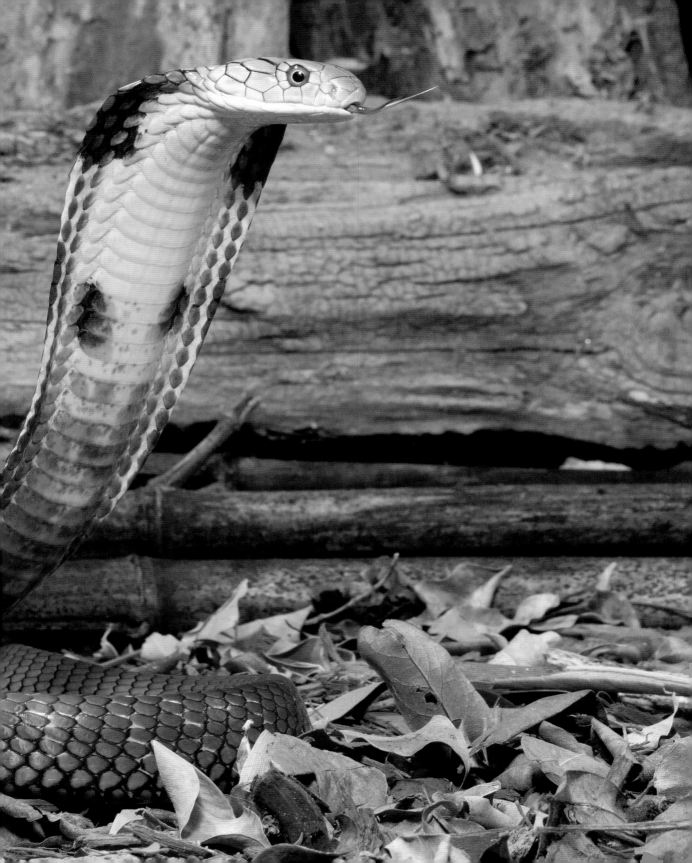

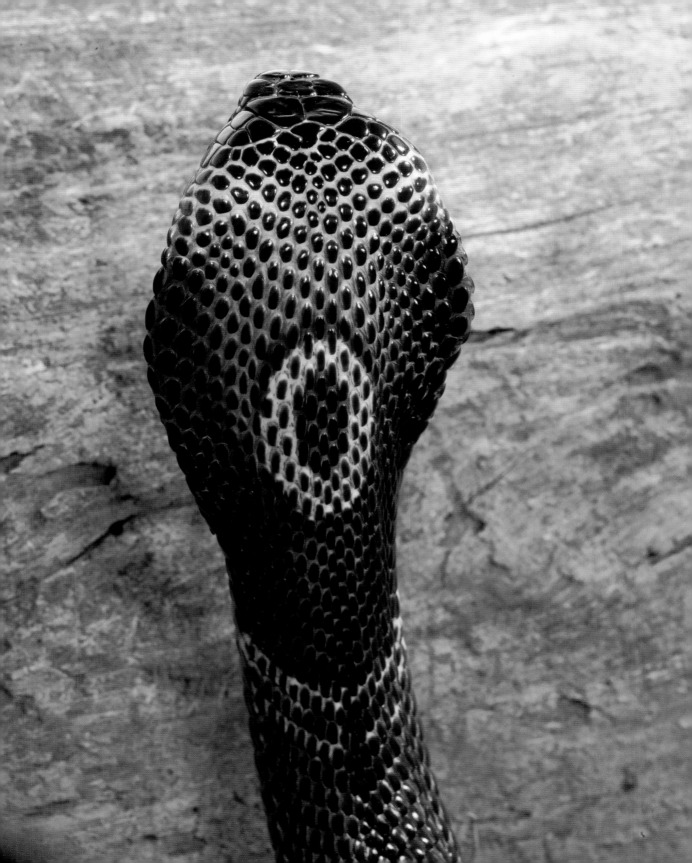

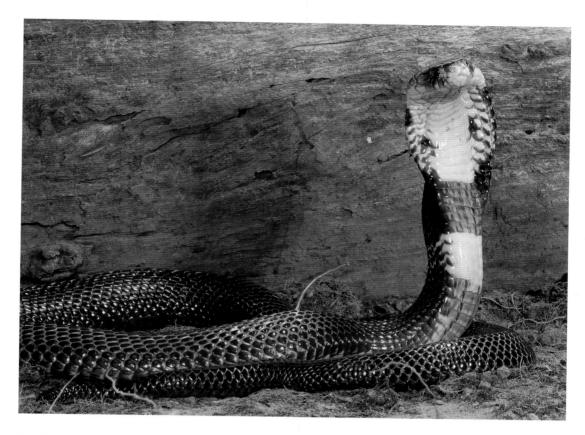

Indian Cobra or Black Cobra
Naja naja

These are the Cobras commonly used by snake-charmers who deceive an audience into believing the snake is weaving in time to the music of the charmer's flute. All snakes are earless, and are therefore deaf to music, although their ribs and bones in the skull can detect vibrations through the ground. Sadly, many of the snakes used in these shows have had their fangs snipped off or their mouths sewn shut to prevent injury to the charlatan. The upright Cobra, weaving back and forth in front of the seated snake charmer, is responding to the swaying of the flutist. The snake's upright stance and widely spread hood is a defensive posture, used to intimidate a potential predator. Some Indian Cobras take this a step further, possessing one or two false eyespots, or spectacles, on the back of the hood. Several species throughout the animal kingdom, from small Pygmy Owls to Four-eyed Toads, utilize this same adaptation, which may protect the animal by deterring attacks from behind. Cobras, along with only three other venomous snake species, account for the majority of snake bite mortalities in South Asia, and untreated bites can have rates of mortality as high as 20 per cent.

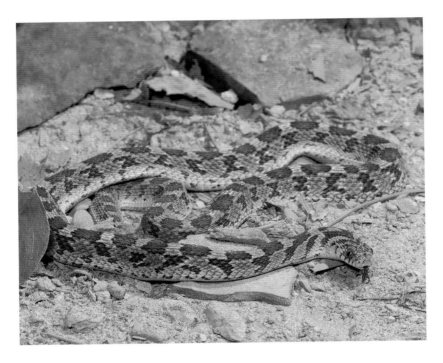

Saw-scaled Viper
Echis coloratus and other Carpet Vipers

These well-camouflaged, ground-dwelling snakes are found throughout much of the drier regions of Africa and Asia. According to some sources one species of Carpet Viper is reputed to cause more human deaths in Africa than any other snake, although another source lists their bites as rare. Either way, these snakes pose a grave threat for anyone walking about bare-foot or in open sandals at night when these small, highly venomous snakes are hunting. Some species, like the Saw-scaled Viper, have keeled scales on their sides which the snake uses to produce a hissing or sizzling sound, a warning to predators to keep away, and a strategy used by the non-venomous Egg-eating Snake, *Dasypeltis scabra*, to mimic these vipers. The Saw-scaled Viper is pictured opposite, while its mimic, the Egg-eating Snake, is shown above.

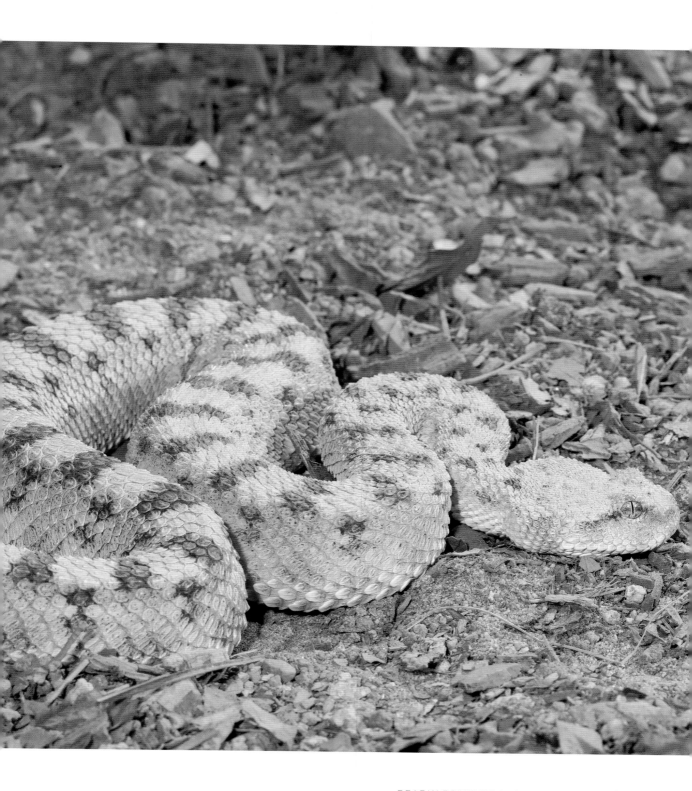

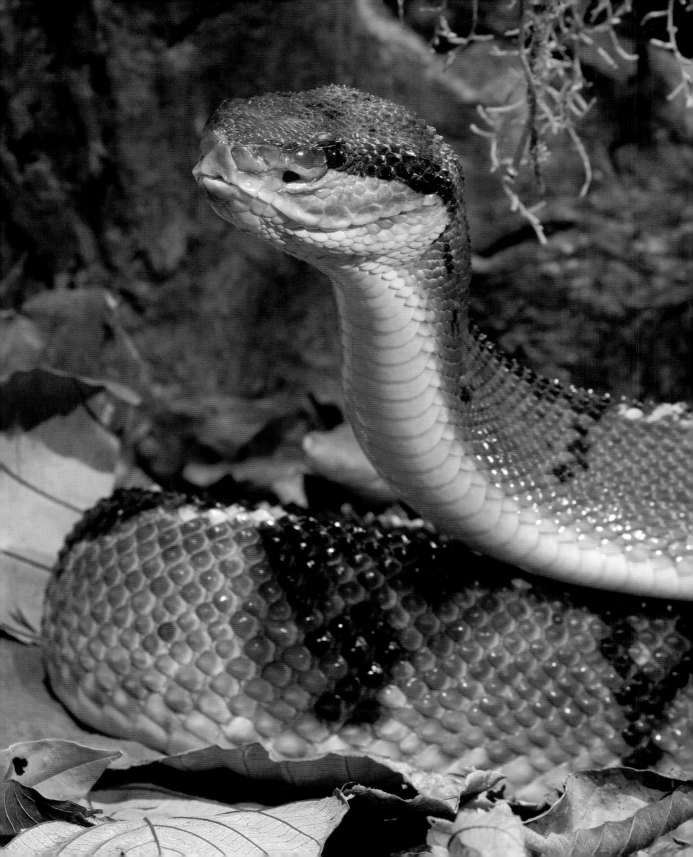

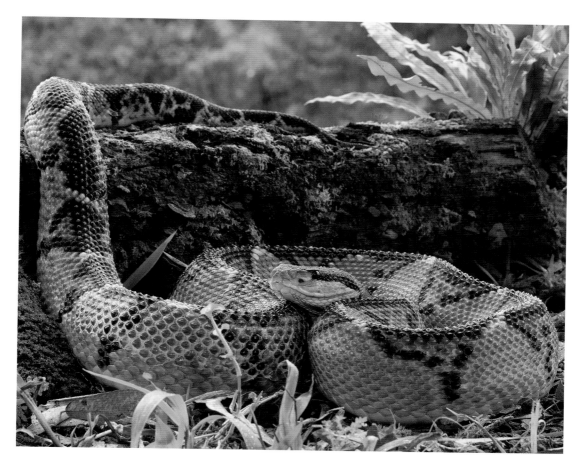

Bushmaster
Lachesis muta

Bushmasters are the largest of all the vipers, reaching lengths of over 3m (10ft), and are exceeded in size only by the Black Mamba and the King Cobra. Bushmasters are pit-vipers, snakes possessing a heat-sensing organ, called pits, which are located between their nostrils and eyes, allowing the snake to strike with accuracy at the heat signature of warm-blooded prey. Unlike most other pit-vipers, Bushmasters lay eggs and like the King Cobra females often remain with their eggs, presumable guarding them from predators. Although Bushmaster venom may lack the potency of other snakes the amount delivered in a bite can more than make up for the difference, and any bite represents a life-threatening event. Oddly, in Costa Rica one study cites a death rate of 25 per cent for Bushmaster bites, while in Brazil the numbers were far lower. In that South American country, in a 4.5-year period 15,000 Bushmaster bites were recorded out of 200,000 venomous snake bites in total, with only 1.4 per cent of people dying as a result.

Fer-de-lance or Terciopelo

Bothrops asper and *B. atrox*

These are perhaps the most feared of all Central American and South
American snakes, getting their two common names from their resemblance
to a lance and for the silky appearance of the skin. These are two of 37
similar-looking snakes in the genus *Bothrops*, which are known commonly as
lanceheads. Because of their size, up to nearly 2m (6.5ft), and the amount
of venom each bite can deliver, the Fer-de-lance is particularly dangerous.
This snake is often found around human habitation where it hunts rodents,
but because of its effective camouflage it is difficult to see, especially at night
when it is most likely to roam.

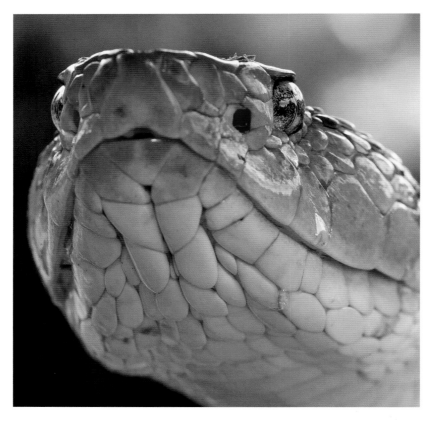

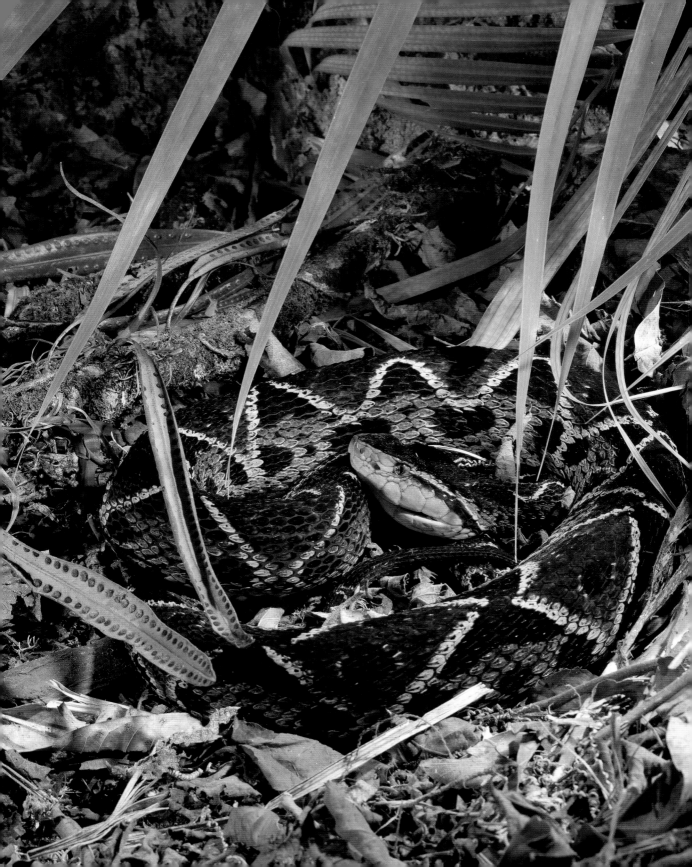

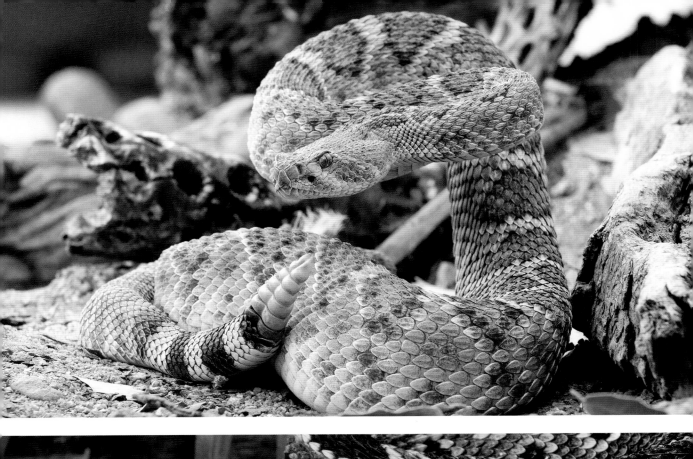
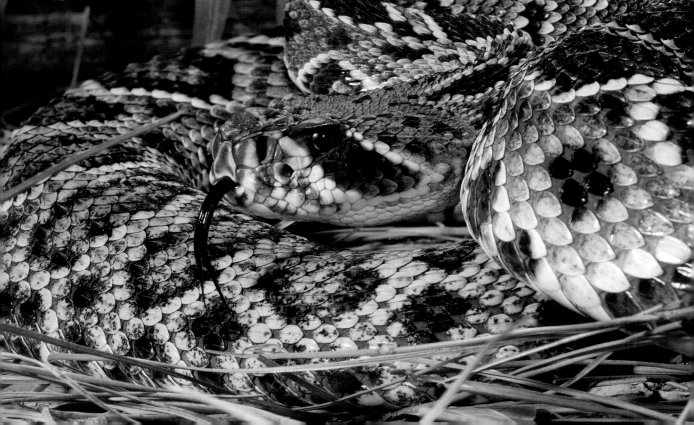

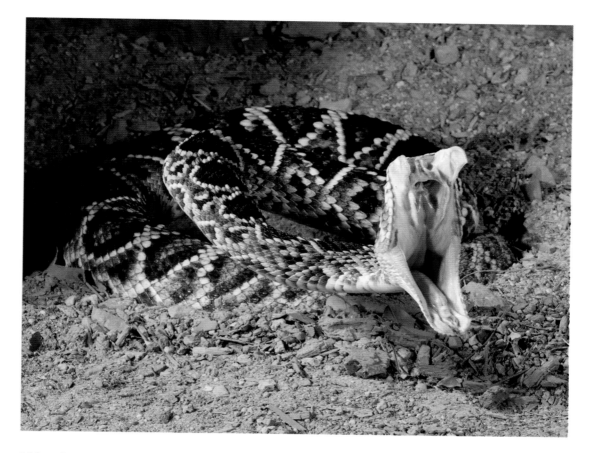

Western Diamondback Rattlesnake
Crotalus atrox

Eastern Diamondback Rattlesnake
C. adamanteus

These two species are the largest of the Rattlesnakes, with the Eastern sometimes growing to over 2m (6.5ft) in length. While the Eastern species is seldom seen, the Western Diamondback often turns up in suburban yards in desert habitats. The rattle of the Rattlesnake makes this group of snakes unique, and is thought to have evolved as a warning mechanism for snakes to avoid being trampled upon by large grazing animals like the American Bison. While Rattlesnakes almost always rattle when annoyed, they may strike without first rattling, especially if caught by surprise such as when they are grabbed or stepped on. The amount of venom either snake injects can be quite large, although that of the Eastern Diamondback is only about one-seventieth as potent as the world's most deadly snake, the Inland Taipan.

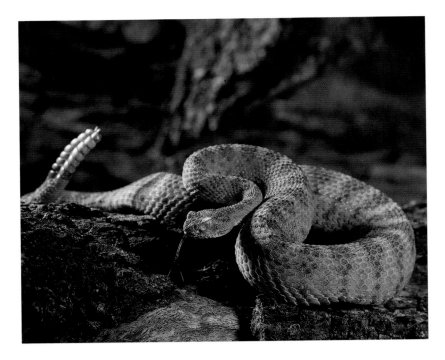

Southern Pacific Rattlesnake
Crotalus oreganus

Tiger Rattlesnake
C. tigris

Canebrake Rattlesnake
C. horridus

Most Rattlesnakes produce haemotoxic venom, one that affects the blood vessels, destroying the lining of these vessels and creating massive haemorrhaging. These three Rattlesnakes, however, also produce neurotoxic venom, or a mixture of both venoms, making them especially dangerous. Some studies suggest that the Tiger Rattlesnake's venom is the most toxic, although the snake is non-aggressive and venom yields are generally small. The Canebrake Rattlesnake, a subspecies of the Timber Rattlesnake, is the most common and widespread species in the eastern United States. It possesses venom which is composed mostly of neurotoxins in certain regions in the southern part of its range, while in other parts of the range the venom is haemotoxic.

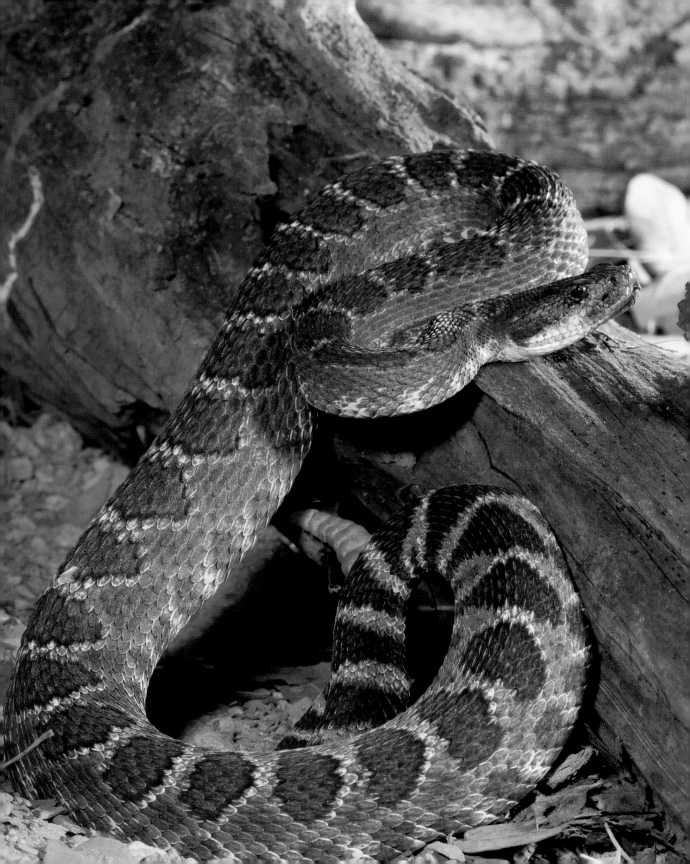

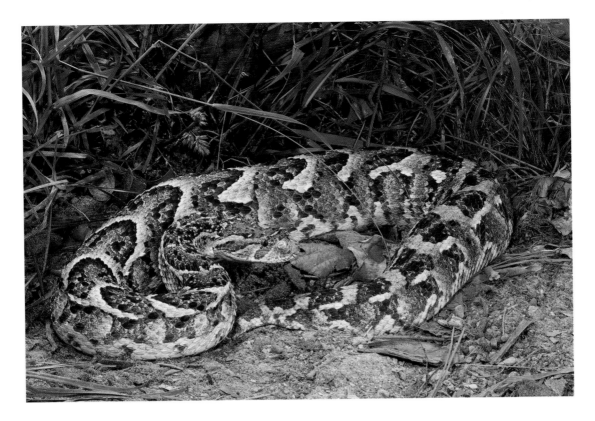

Russell's Viper
Vipera russelli

Puff Adder
Bitis arietans

These two species, the Russell's Viper of the Indian Subcontinent and the Puff Adder of sub-Saharan Africa, are among the world's most deadly snakes, responsible for many of the deaths from snake bites throughout their respective ranges. Both snakes are thick-bodied, stout snakes with huge heads and the Puff Adder in particular seems to be practically invisible when it lies among grasses and rocks. Russell's Vipers are frequently found around human habitation, as the large and more dangerous adults seek the rats and mice found there. Puff Adders, fortunately, are most frequently found in grasslands, but they often show up in safari lodges and camps in East Africa, much to the horror of some tourists. Puff Adders hiss explosively when disturbed, and can strike with great force.

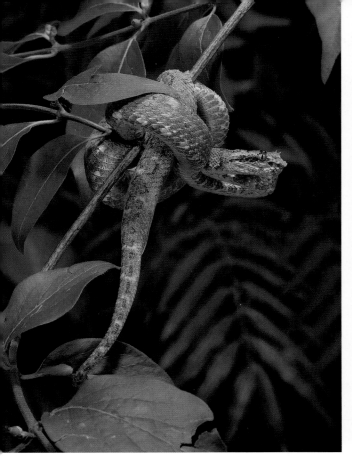 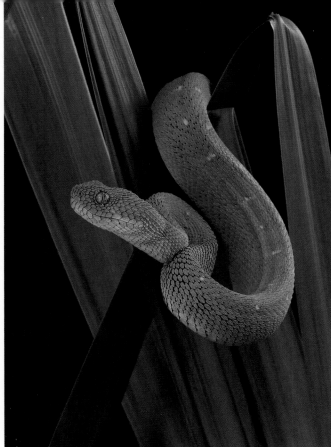

Tree Vipers including African Bush Viper
Atheris squamiger

Wagler's Viper
Tropidolaemus wagleri

Eyelash Viper
Bothriechis schlegelii

In tropical and subtropical forests and woodlands around the world there are a variety of colourful tree vipers which lay coiled and waiting for a passing bird, treefrog or lizard. Despite their often brilliant colours, in their natural habitat these vipers can be surprisingly difficult to see. Most of the time they remain motionless as they wait in ambush for their prey, but that same trait can bring them into conflict with humans, who may reach out to pluck a flower or lay a steadying hand upon a tree limb and trigger a bite from the surprised reptile. Because of the size and relatively weak venom, most tree vipers pose minimal danger to humans, but a small-bodied person bitten by a larger snake, especially around the face or neck, could be in mortal danger.

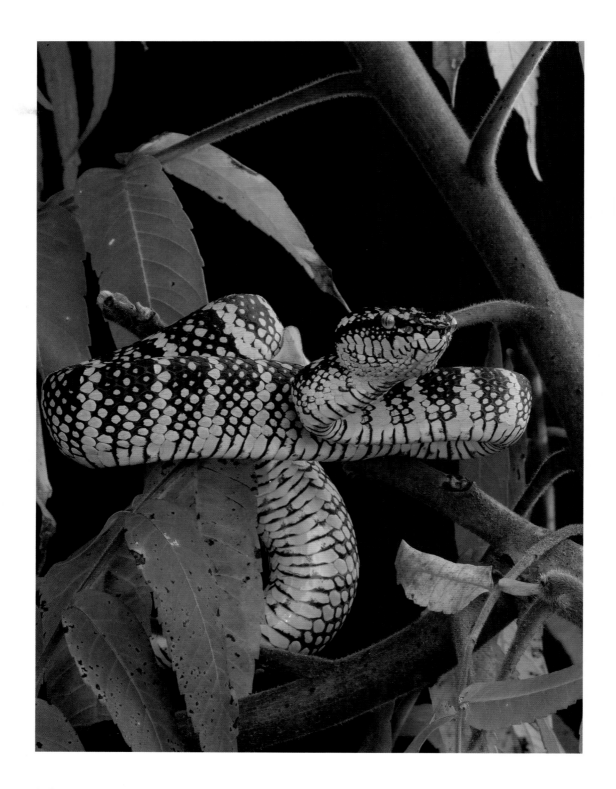

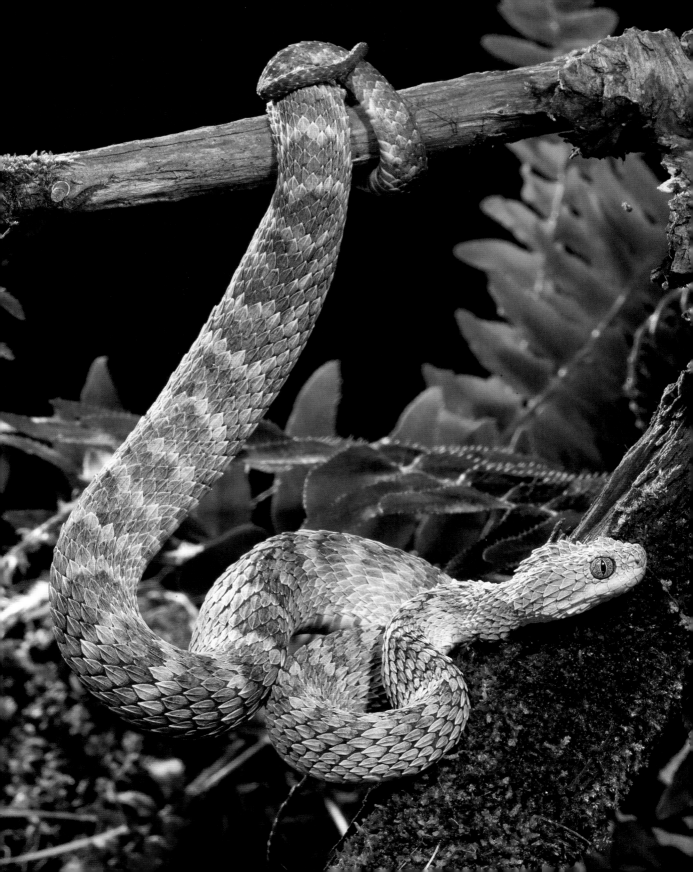

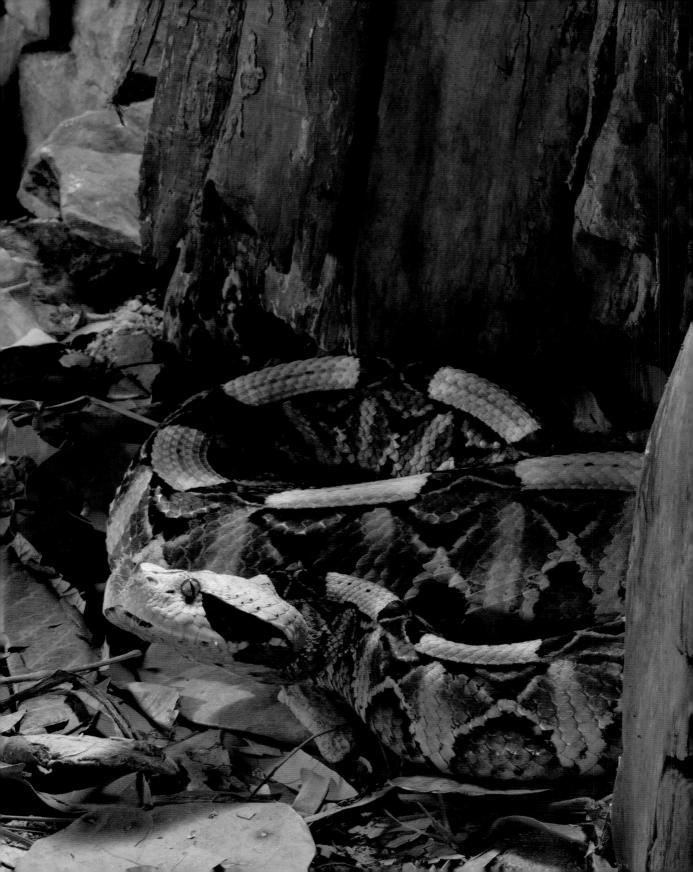

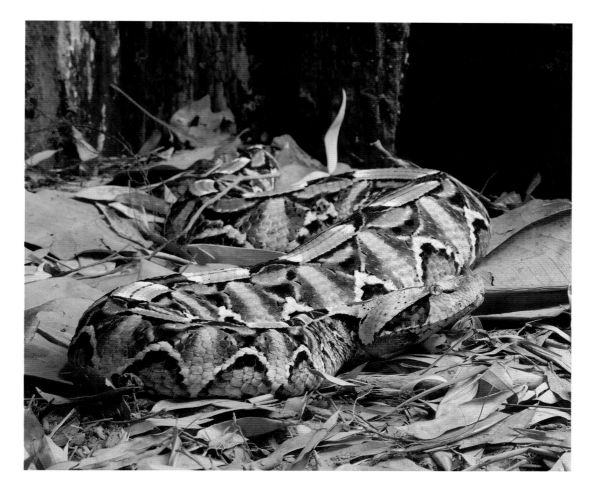

Gaboon Viper
Bitis gabonica

This huge-bodied venomous snake is found in the tropical forests of Central and Western Africa, were it is rarely seen because of its extremely cryptic colouration. Most bites occur because someone stepped on this well-camouflaged snake. Gaboon Vipers often hang on after biting, allowing the viper to pump in a considerable amount of venom, more than any other venomous snake. Various studies have concluded that as little as one-fiftieth of the total volume of venom a Gaboon Viper may store in its venom glands is sufficient to kill a 70kg (150lb) human. Gaboon Vipers seem remarkably docile, but they can strike with lightning fast speed, amongst the fastest of all snakes. A friend, who owns a Reptile Zoo, educates his potential snake keepers by giving one of their larger Gaboon Vipers a large rat. The sleepy-looking snake always strikes in a flash, killing the rat almost immediately. That, he says, always generates the respect and caution this snake deserves.

Eastern Brown Snake
Pseudonaja textilis

Australian King Brown Snake
Pseudechis australis

Australia has the dubious distinction of hosting some of the most deadly venomous snakes in the world, and the Eastern Brown Snake is one of the most deadly. Although both of these species are known as 'brown' snakes, the two belong to different genera, just as a fox is distantly related to a dog. All of Australia's venomous snakes belong to a large group of short-fanged, venomous snakes called the Elaphidae, the same family that has King Cobras, Indian Cobras, Kraits and Coral Snakes as members. While the King Brown Snake's venom is not particularly potent, it is the second longest venomous species in Australia and the huge quantities of venom that it can deliver in one bite makes it quite dangerous. The Eastern Brown, considered the second most deadly venomous snake in the world, often, when biting defensively, delivers 'dry' bites, where no venom is injected, at least for the first few snaps. If the snake is still annoyed or detained a venomous bite may follow, and left untreated, the bite is likely to be fatal. When provoked, the Eastern Brown Snake may rear up high in a defensive S-shaped curve, but unlike a Cobra the snake does not spread out a hood. Nonetheless, when one sees a Brown Snake rearing, it is time to back off! Approximately half of the fatal snake bites in Australia are the results of bites from the Brown Snakes, but it must be noted that most snake bites, in Australia and in most developed countries, occur when a person tried handling or killing the snake.

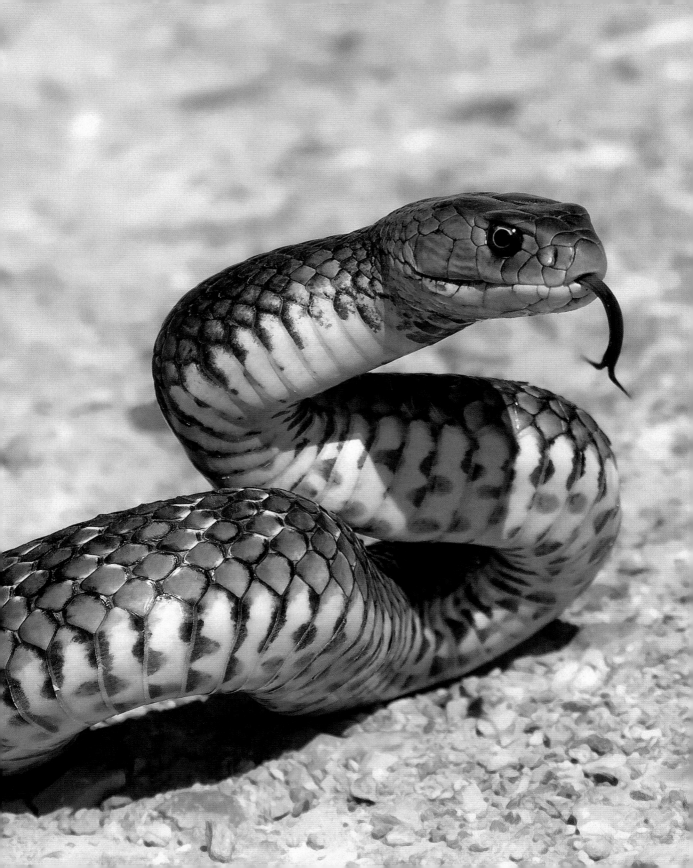

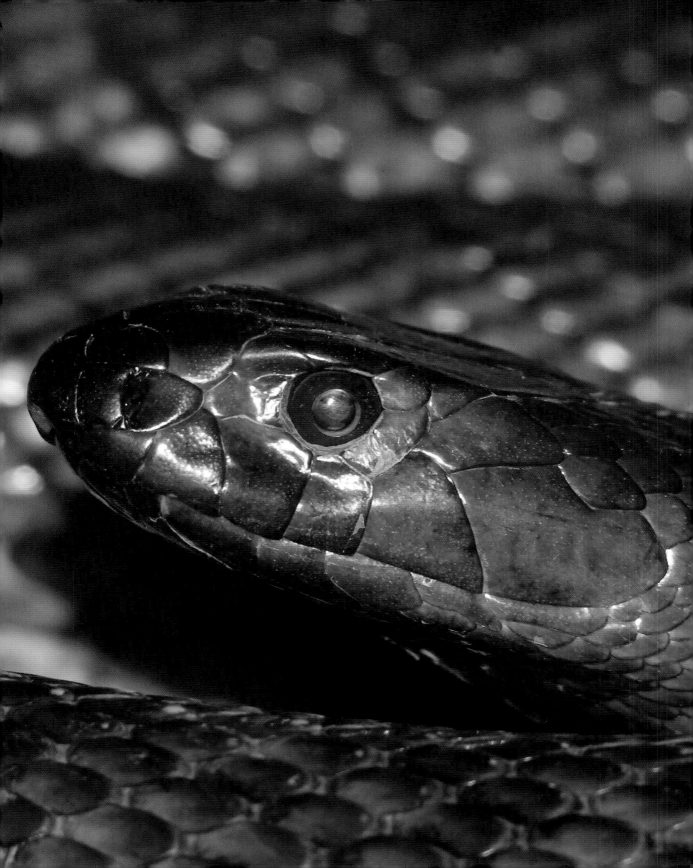

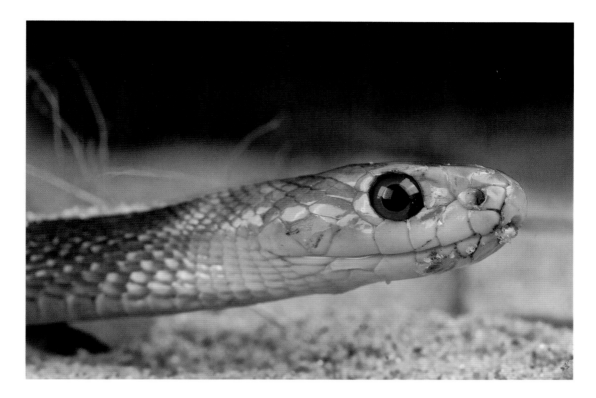

Inland Taipan
Oxyuranus microlepidotus

Coastal Taipan
O. scutellatus

The Taipans are large venomous snakes, with the Coastal Taipan, the longest venomous snake in Australia, reaching lengths approaching or exceeding 3m (10ft). The venom of the Coastal Taipan is nearly always fatal if not treated by antivenom, with deaths often occurring in less than three hours, and sometimes in as little as 30 minutes. The Inland Taipan is even more deadly, and is the most venomous snake in the world. One bite from an Inland Taipan delivers enough venom to kill an incredible 200,000 mice, or 100 adult men. Fortunately this snake of Australia's semi-arid interior is not aggressive, but if cornered this Taipan will bite, and most bites deliver venom. Scientists ponder as to why some snakes produce such toxic venom, with potencies far exceeding the need to kill or to subdue their prey. Perhaps the toxicity relates to the need for a potent defensive mechanism, but then the question arises, why are other species less venomous?

Kraits
Bungarus species

Several species of this often-colourful ground-dwelling snake family occur in South-east Asia and India, where these and three others are responsible for nearly all snake bite fatalities. Potency varies, but some species are considered among the most venomous species in the world. In 2001, a prominent American herpetologist, Joseph Slowinski, was bitten on the finger by a juvenile Banded Krait less than 25cm (10in) long, and although the snake held on to the digit for nearly ten seconds no fang marks were visible and it was hoped that the snake had not broken through the skin. It had, and in less than 30 hours the herpetologist was dead. Kraits, like American Coral Snakes and several other venomous species, including the Saw-scaled Viper, have very convincing mimics, which protect these non-venomous species from some degree of harm. It was uncertain whether the captured snake that killed the herpetologist was a Krait or its mimic but he reached into the bag anyway, and paid dearly for it.

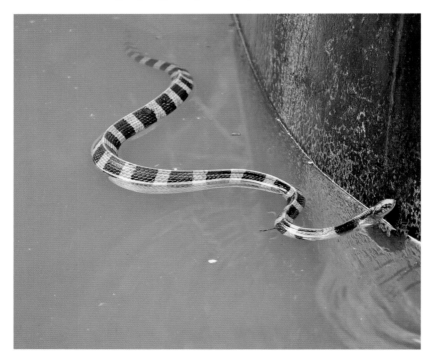

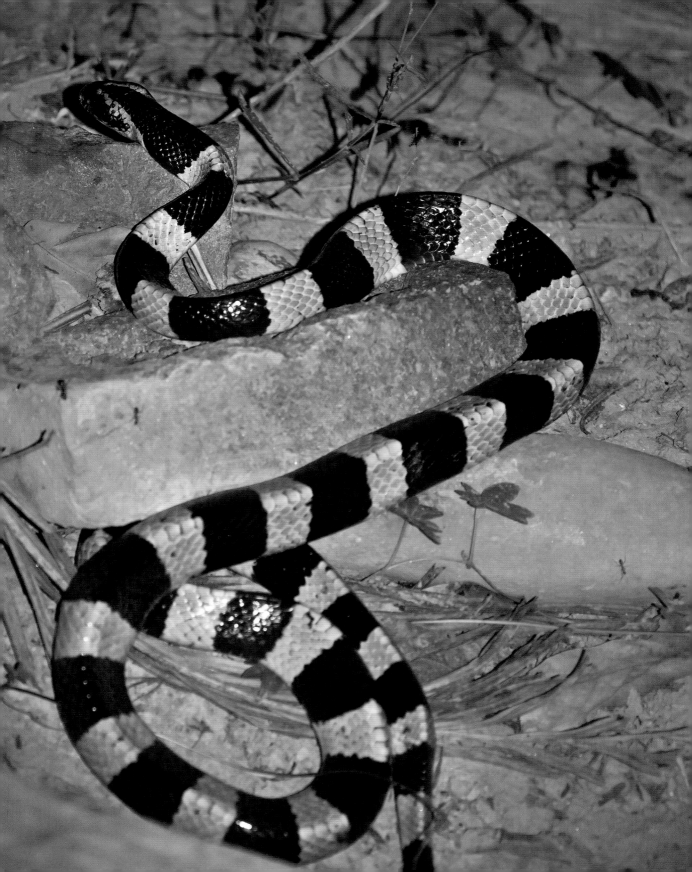

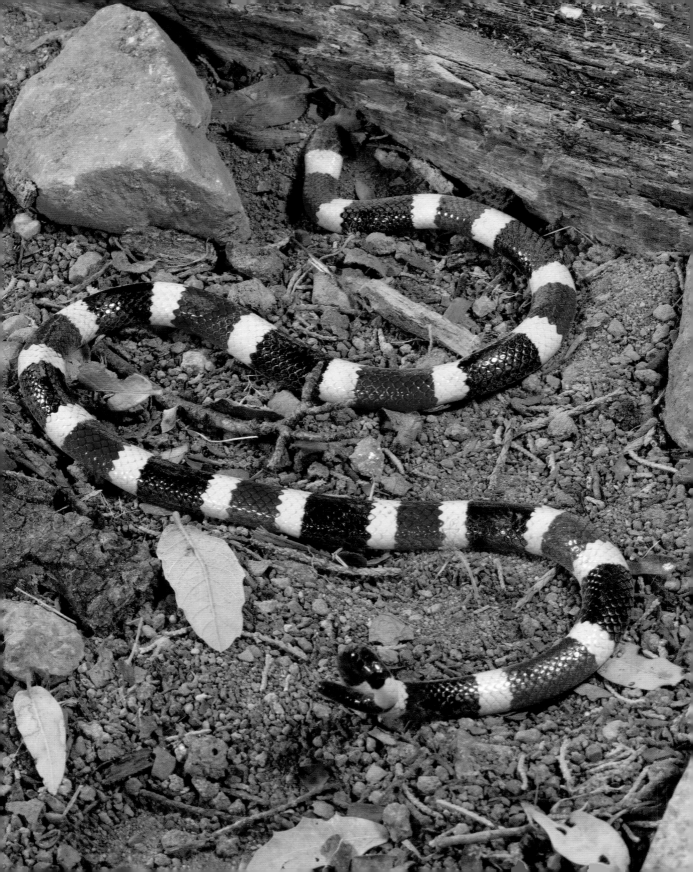

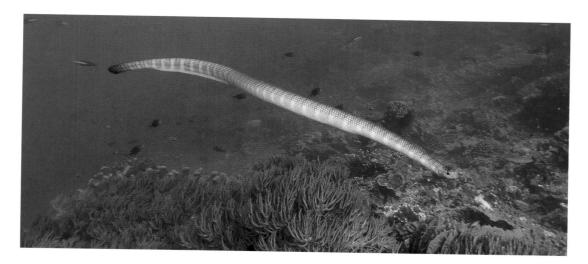

Coral Snakes
Micrusus species

'Red to yellow, kills a fellow, red to black, venom lack.' That little ditty is a great way to separate the venomous Coral Snakes found in the United States from their non-venomous mimics. Unfortunately this rule does not apply universally, as many of the Central American and South American Coral Snakes have a variety of colour patterns that defy an easy mnemonic. Coral Snakes are shy and retiring, spending their time in the leaf litter on the forest floor as they hunt small lizards and snakes as prey. Because of their attractive colours young children sometimes play with Coral Snakes, much to their parents' horror, but luckily the snakes seem oddly tolerant and rarely bite. The Sonoran Coral Snakes of America's south-west have an odd defensive behaviour, curling their tail and making a weird cloaca 'pop' that might distract a predator. Coral Snakes are mimicked by several species, but oddly, some of these mimics, like the Arizona Mountain King Snake, live in higher elevations than the species they are supposed to mimic.

Sea Snakes
Pelamis platurus and other species

There are indeed sea serpents in the world's oceans, but not the huge mythological beasts that come to mind. In fact, there are 62 species of Sea Snake, and all are venomous, with some having venom that is extremely toxic. The Yellow-bellied Sea Snake, the only species found in the eastern Pacific, has venom more potent than any of Costa Rica's land snakes, and that includes the world's largest pit viper, the Bushmaster, and the much feared Fer-de-lance. Birds that might otherwise eat snakes, like coast-hunting herons and egrets, avoid the Yellow-bellied Sea Snake, apparently recognizing the potential danger it poses. Most Sea Snakes are mild-tempered and rarely bite, although three or four species are the exceptions. A bite could be deadly as the snakes are neurotoxic, much like the Cobras and Kraits.

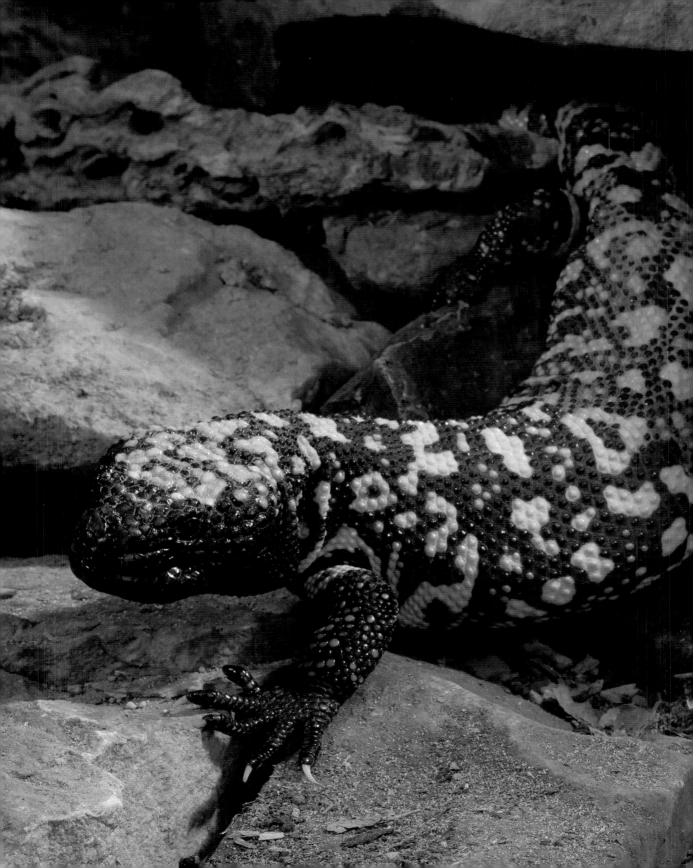

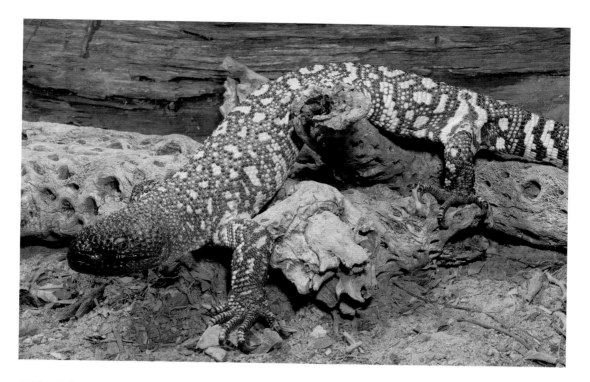

Gila Monster
Heloderma suspectum

Beaded Lizard
Heloderma horridum

There are only two truly venomous lizards in the world and both live in a relatively restricted area, the south-western United States and north-western Mexico for the Gila, and western Mexico south into Guatemala for the Beaded Lizard. Both are relatively large, stout lizards, with the Beaded growing to nearly 1m (3.3ft) in length while Gila Monsters grow to just half that size. Unlike snakes, which evolved venom as a means to subdue or capture prey, the venom of these two lizards was probably developed as a defensive weapon. In further contrast, the venom glands of these lizards are located in the lower jaw, not in the upper, and envenomation requires the lizard to bite, chew and hang on, sometimes for ten minutes or more, giving the lizard plenty of time for the venom to work its way into a wound. Nearly all bites from Gila Monsters are due to people handling the lizard in some way, and a recent study of 17 bites revealed that 14 of these involved lizards that were kept as pets or used in demonstrations. Bites from wild lizards that were not harassed or touched are virtually unknown. This likely applies to the larger Beaded Lizard as well, but this lizard is even more dangerous, and fatalities have resulted from its bite.

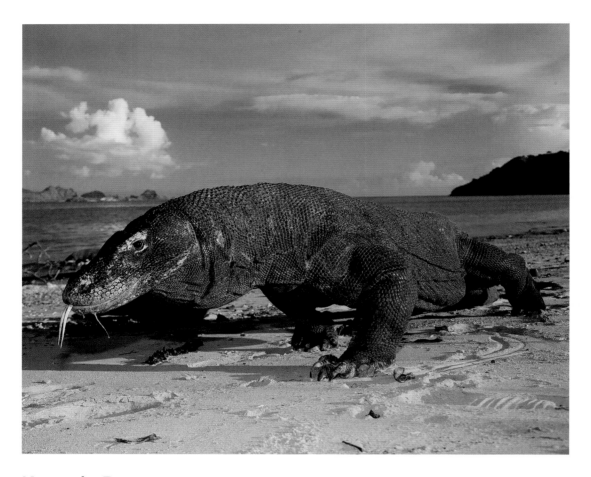

Komodo Dragon
Varanus komodoensis

This monitor is the world's biggest lizard, with the largest recorded growing to over 3m (10ft) in length. Komodo Dragons are the top predator in their ecosystem, which includes the island of Komodo and the much larger Flores Island, where their principle prey are deer, wild pigs, and occasionally even Water Buffalo. Komodo Dragons may unintentionally work together to attack large prey like Buffalo, but most kills are made by solitary animals taken in ambush, although the lizard is capable of surprising speed as it rushes prey. With sharp, serrated teeth and powerful jaws, the bite of this lizard could alone be deadly, but toxic proteins are also found in its saliva. Many scientists argue that the lizard is indeed venomous, besides having as many as 57 bacteria strains in the saliva of some Dragons that would contribute to infections leading to death. Komodos have killed people, including, it is suspected, a European tourist on Komodo Island who wandered away from his group.

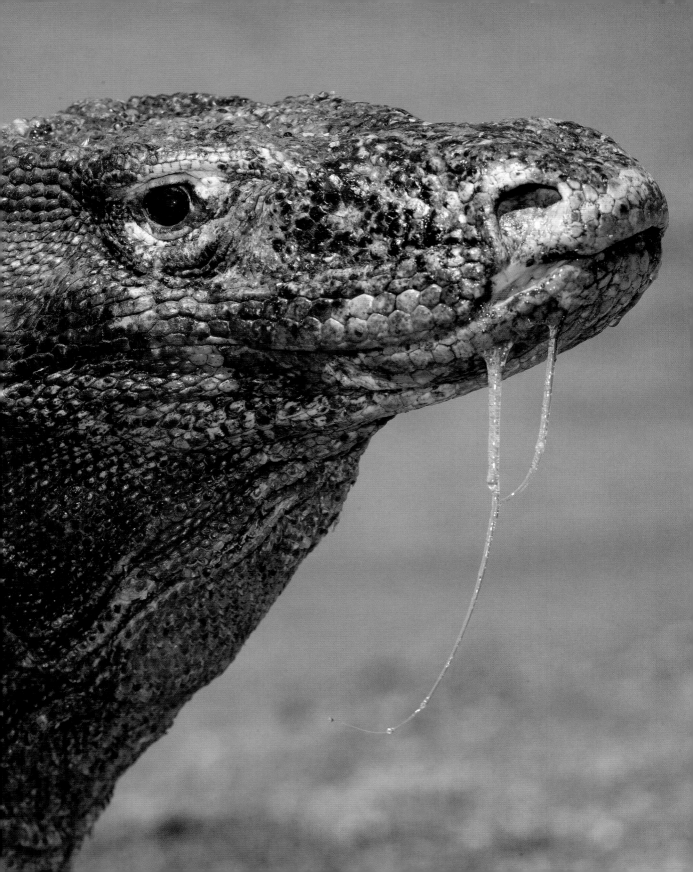

Poison Dart Frogs
Phyllobates and *Dendrobates* species

All of the reptiles described have been venomous, biting or injecting venom into a wound. In contrast, certain amphibians, like the Dart Frogs are actually poisonous, requiring the frog or its skin or poison to be ingested – eaten, or injected, as from an arrow or dart. Most of the Poison Dart Frogs are brightly coloured and are clearly visible on the forest floors of Central and South America, where their conspicuousness advertises a clear warning to would-be predators. One species, the Golden Dart Frog, is more toxic than the venom of the Inland Taipan, the world's most venomous snake, and the skin secretions of the average Golden Dart Frog have enough toxicity to kill as many as 20 humans. Indigenous people of Colombia use the secretions from the Golden Dart Frog to poison the tips of their arrows and darts for use in hunting. Wild-caught Dart Frogs may maintain their toxicity for several years when in captivity, but captive-born frogs are not poisonous. It is assumed that the Dart Frogs derive the alkaloids used in their poison from species of ants or beetles, food items which are not available to the captive frogs.

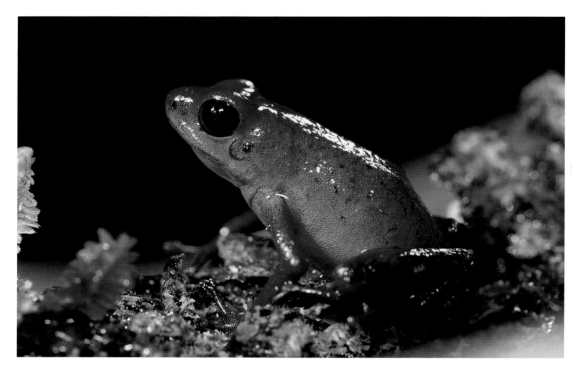

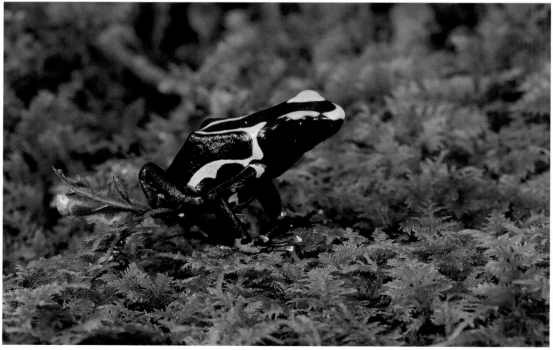

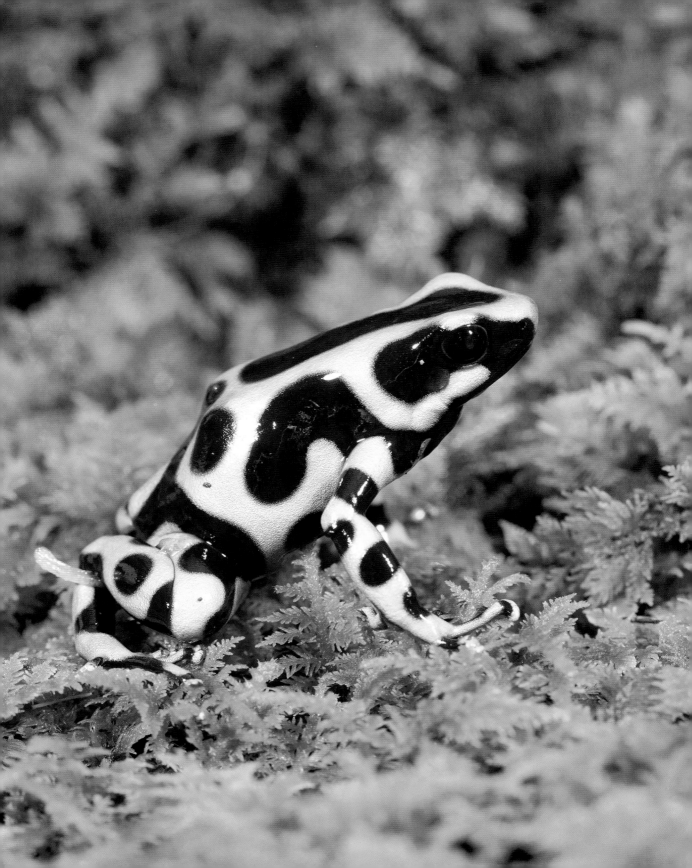

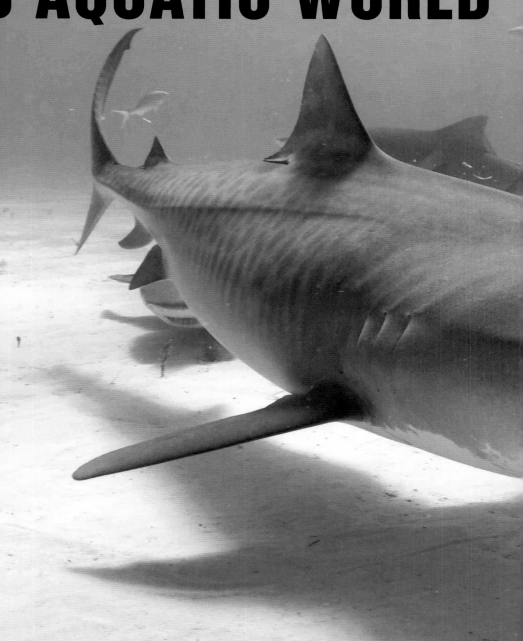

THE DEADLY MARINE
AND AQUATIC WORLD

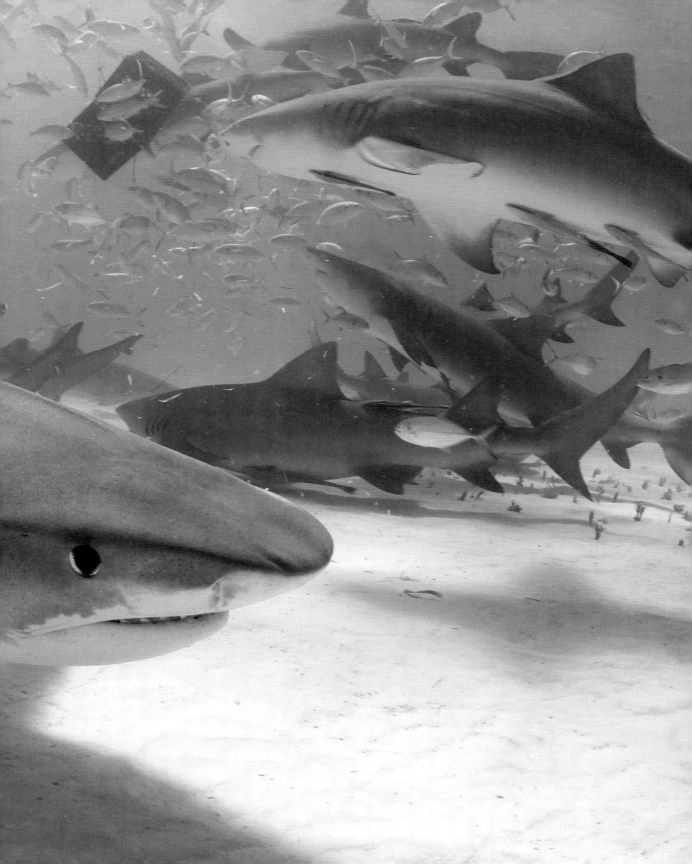

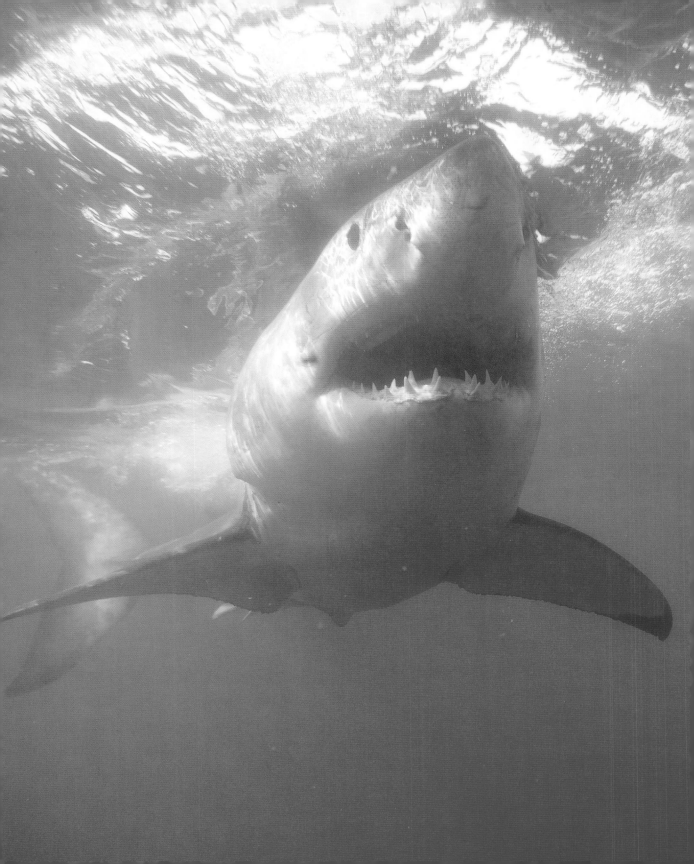

CHAPTER FOUR
THE DEADLY MARINE AND AQUATIC WORLD

I had just seen the movie *Jaws*, only days before my college friends and I began a long cross-country trip through Mexico and Central America. During our travels we stopped along the shores of Lake Nicaragua, which is known to host the aggressive and deadly Bull Shark. Nonetheless, we decided to go swimming and as I waded in, with the water just about mid-thigh, something hard bumped me from behind. With that movie still on my mind I literally did a flip in the air, scared out of my skin, only to find that a water-soaked tree trunk had banged against me.

Of course, only my pride and tranquillity had been affected, but the outcome could have been quite different, if an unseen, powerful Bull Shark had actually made an appearance. Since then, Mary Ann and I have spent time in a shark cage in South Africa with the largest of all the predatory sharks, the Great White Shark, and one individual tried its best to wedge its conical snout between the bars that separated us. While we felt reasonably safe inside the cage, the sight of a 3–4m (10–13ft) shark suddenly materializing from the murky green-blue water, black eyes staring and a tooth-filled mouth gaping widely, is one experience we'll never forget.

We are only transient visitors to the underwater world, a landscape hosting dozens of potentially deadly creatures. Some, like the Great White Shark, the Bull Shark, and others, will consider a swimmer, boater, or wader as a potential meal, but the majority of sea and freshwater creatures seek only to be left alone, and trouble results when the curious or aggressive person puts themselves in harm's way. Sometimes that might be as innocent an act as to swim too close to a tiny Jellyfish, or as stupid as teasing a Moray Eel or a Blue-ringed Octopus.

While most of the deadly creatures I've covered involved specific species, be that the poisonous Golden Dart Frog, the venomous Inland Taipan, a rogue African Elephant or an ageing man-eating Tiger, the marine environment encompasses whole groups of animals, entire genera and families, that are potentially deadly to humans. Scorpionfish of a variety of colours and shapes await the incautious wader or diver that steps upon one of these spiny, venomous fish, while slow-moving and attractively patterned Cone Shells meander along the ocean floor, tempting a human observer for a closer look. These snails pack a deadly harpoon that might impale someone's hand, delivering a lethal dose of venom in doing so.

I'm sure that many people reading this book have experienced the surprising stings from a Jellyfish's tentacles, as these strange sea-dwellers are found worldwide in virtually every saltwater habitat, from the most remote ocean depths to the shallow waters off the most popular tourist beaches. Indeed, perhaps an exposure to a jellyfish's stings are the closest you will ever actually come to meeting any deadly sea creature, but the sea is filled with other characters. There are venomous Shrimps and Sea Urchins, painfully stinging Corals and Starfish, deadly venomous Catfish, and Sharks, Rays and Sea Snakes, all part of an alien but natural world that we can only experience as temporary visitors, a world laden with the potential of many unpleasant surprises to the incautious or the ill-informed.

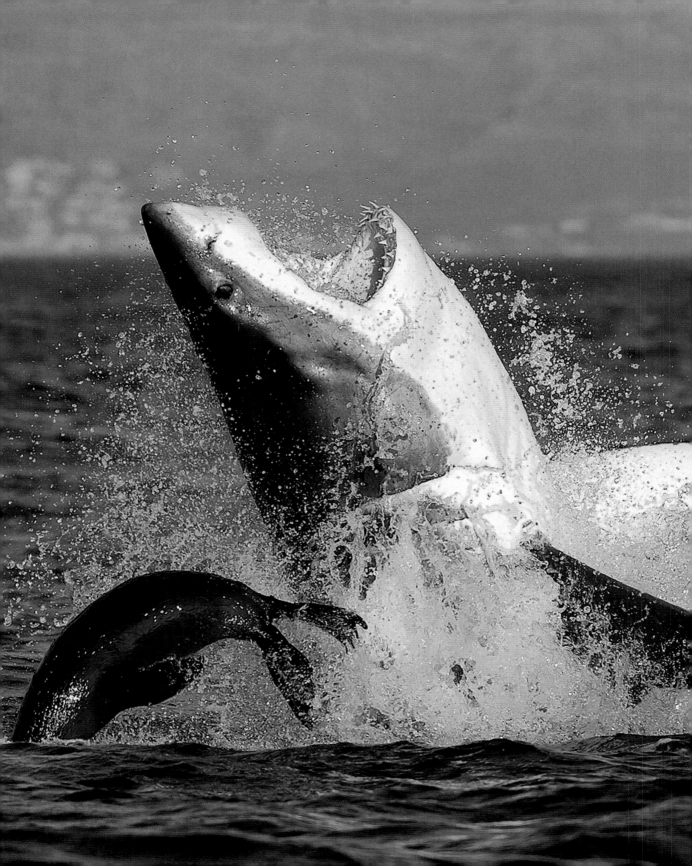

THE DEADLY MARINE AND AQUATIC WORLD
THE SPECIES

Great White Shark
Carcharodon carcharias

Seen from below, the silhouette of a Fur Seal floating in the sea resembles, too closely, a man or woman on a surfboard, paddling along with arms and legs extended. To the Great White Shark, a Seal is a meal, and so too may be anything remotely resembling its normal prey. The book and the movie *Jaws* catapulted this mega-predator to worldwide infamy, but the risk of actually being killed by any shark is hundreds of times less than the risk of being struck by lightning. Nevertheless, the Great White Shark has been involved in more attacks on humans than any other species. Many shark 'attacks' may actually be exploratory bites, where a shark takes a snap at a victim, testing it out as a possible meal, but with the Great White's huge jaws and rows of serrated teeth even an exploratory bite may prove fatal. Great Whites can be huge, and are the largest of all macropredatory fish, those that typically eat large prey. Great White Sharks grow to at least 6m (20ft) in length, and possibly to as long as 8m (26ft). Western Australia and South Africa, both known for their populations of Great White Sharks, have had the highest fatality rates from shark attacks, with nearly 30 per cent of these attacks ending in death.

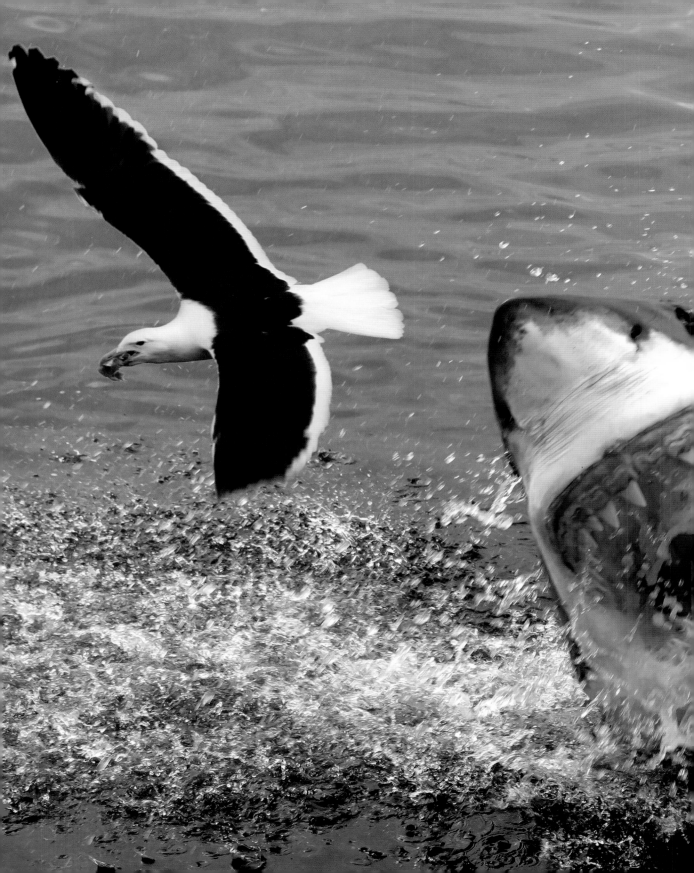

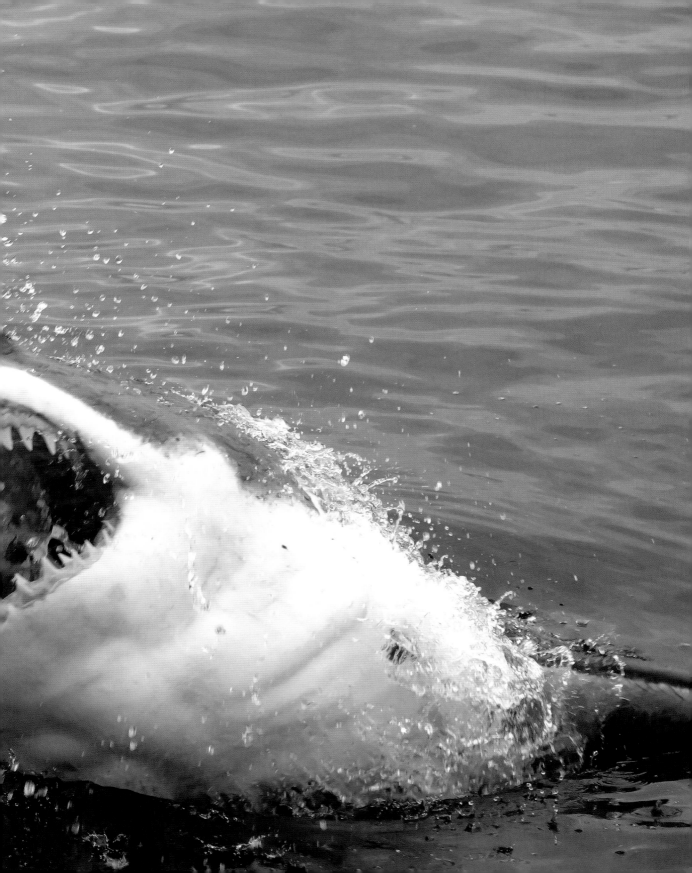

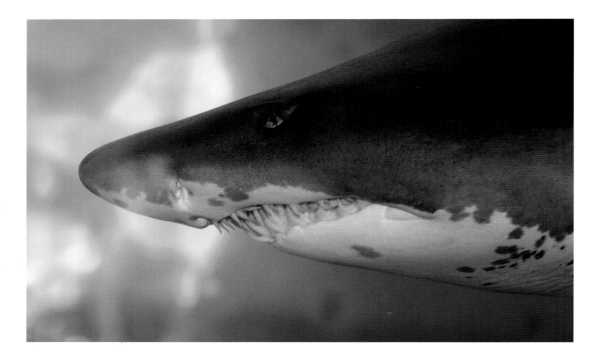

Tiger Shark
Galeocerdo cuvier

Whitetip Shark
Carcharhinus longimanus

Bull Shark
C. leucas

Several other large species of Shark pose a deadly threat to humans, and the species involved is often dependent upon where the victim happens to be. Off the islands of Hawaii Tiger Sharks have been involved with the most fatalities, while in the open ocean or around reefs Whitetip Sharks are likely to be involved. Bull Sharks, however, may be the most threatening, as this Shark readily swims up coastal rivers and into estuaries and bays, even entering freshwater at times to hunt for prey. Central America's Lake Nicaragua has a notorious population of Bull Sharks that migrate between the Caribbean and the lake. There are several reports of Bull Sharks swimming far up rivers in New Jersey where they have fatally attacked humans. Bull Sharks have been recorded as far north as Illinois on the Mississippi, as far inland as 4,000km (2,500 miles) up the Amazon River, and they are also found in rivers in Africa and Australia, making the Bull Shark a very deadly menace both in saltwater and fresh water.

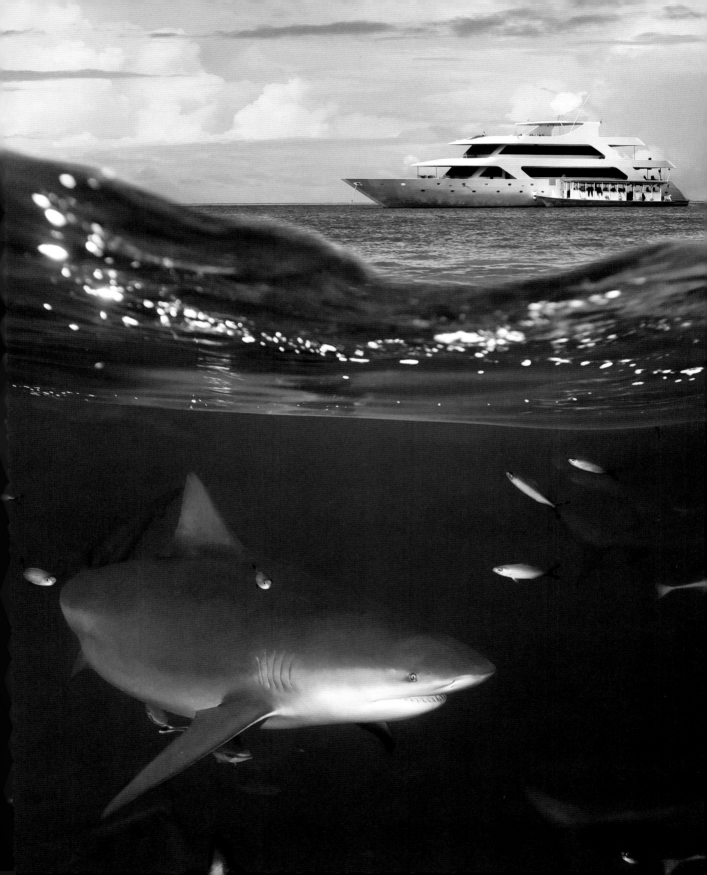

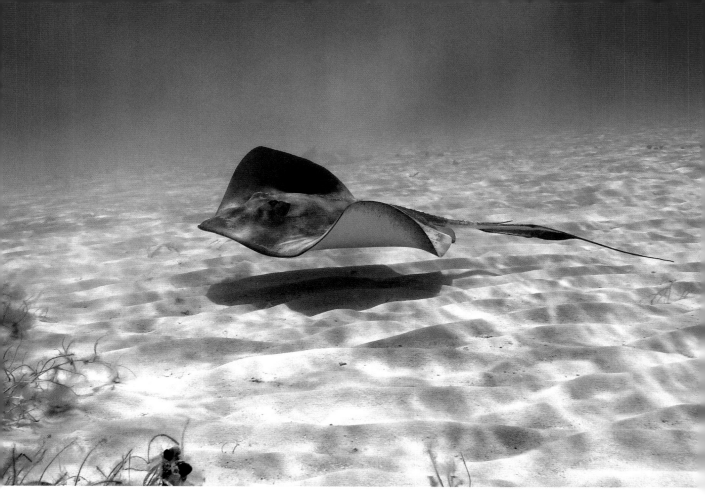

Stingray
Dasyatis pastinaca and other species

The oddly shaped Stingray, like its cousin the huge Manta Ray and the similar looking Skates, are all flattened fish relatives of the Sharks. All belong to a group known as the cartilaginous fishes, the Chondrichthyes, while salmon, bass, tuna, minnows, goldfish and others are true bony fishes, belonging to the Class Osteichthys. Many rays possess a stinging barb, giving these species their collective name of Stingray, with the barbs of some species reaching over 0.3m (1ft) in length. The barb, equipped with venom glands, is a purely defensive weapon, often used when someone inadvertently steps upon a well-camouflaged Stingray lying buried in the sand. At beaches where Stingrays are common, bathers are advised to shuffle their feet through the sand when moving through shallow water so as to bump and spook the fish away, rather than to accidentally step upon a Stingray and be stabbed by a surprised fish. Most jabs simply result in a painful wound, but one of Australia's most famous wildlife TV personalities, Steve Irwin, was killed by a Stingray that slammed its barb into his chest.

Lionfish
Pterois volitans and other species

This beautiful, ornately finned fish aptly illustrates the adages that it is best to keep your hands to yourself, or curiosity kills the cat, and if a Lionfish is left alone, a swimmer, diver or fisherman has nothing to fear. However, touching a Lionfish, perhaps while diving or removing one from a fishing line or net, may bring someone into contact with their venomous spines. Lionfish belong to a larger group called the Scorpionfish, one member of which, the Stonefish, is one of the most venomous of all fishes. Unlike the Lionfish, which is quite visible as it hunts around coral reefs, the Stonefish is an ambush predator and consequently is extremely well camouflaged. Swimmers, stepping upon rocks or coral, may inadvertently step upon a Stonefish and be stabbed, and the injury can be fatal. Lionfish, because of their unique shape and colours, are popular saltwater aquarium pets, and unfortunately, either intentionally or by accident, this fish has been introduced into the waters off Florida and into the Caribbean. Here the Lionfish has no natural predators and their population has exploded, resulting in a decline of over 80 per cent in native reef fish populations in some areas as this fish preys upon the native species. It is considered a true marine disaster story for these regions, with little hope in sight as the Lionfish continues to expand its new range.

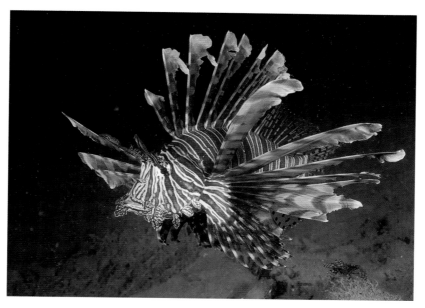

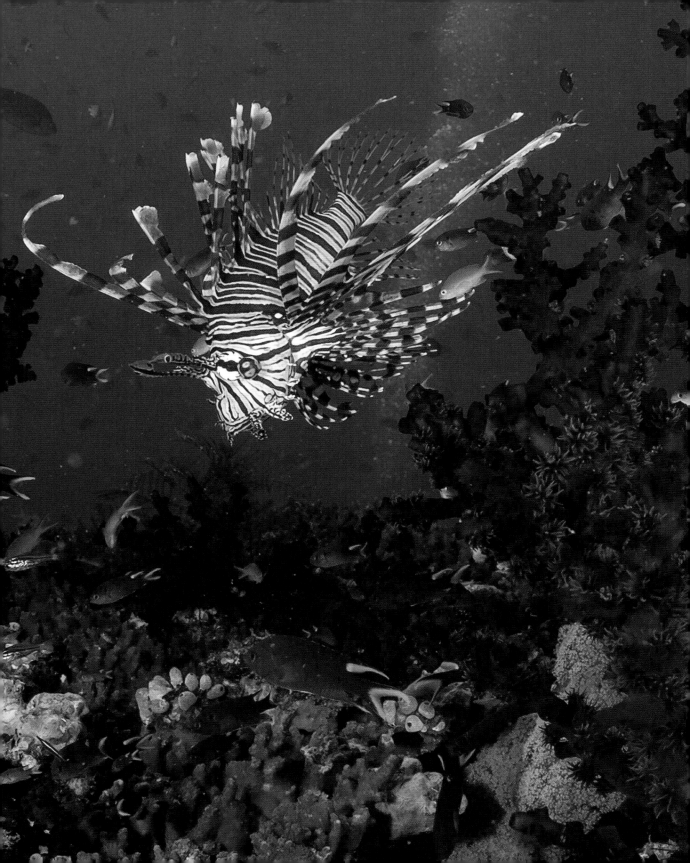

Porcupinefish
Diodon hystrix

Pufferfish
Sphaeroides maculatus and other species

Perhaps anyone dying from the poison of one of these fishes is getting a post-mortem payback from the fish, as fatalities from these deadly fish only occur if a fish is eaten. Pufferfish are extremely poisonous, and second only to the amphibian, the Golden Dart Frog, as the most poisonous vertebrate. Almost all of the fishes in this group defend themselves by inflating to a larger size, either ingesting water or air to greatly expand their volume, making it more difficult for a predator to grab or to swallow. If ingested, however, the toxins found in the fishes' liver and skin may sicken or kill their attacker. In Japan Pufferfish are served as a tempting delicacy, either as a soup or as sushi, and only specially trained chefs prepare the dish. Accidents happen, especially for anyone preparing the fish at home, and paralysis of the diaphragm may suffocate unlucky diners.

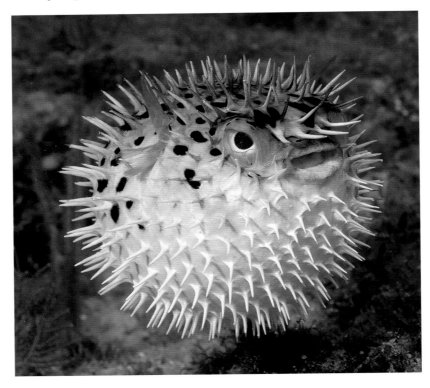

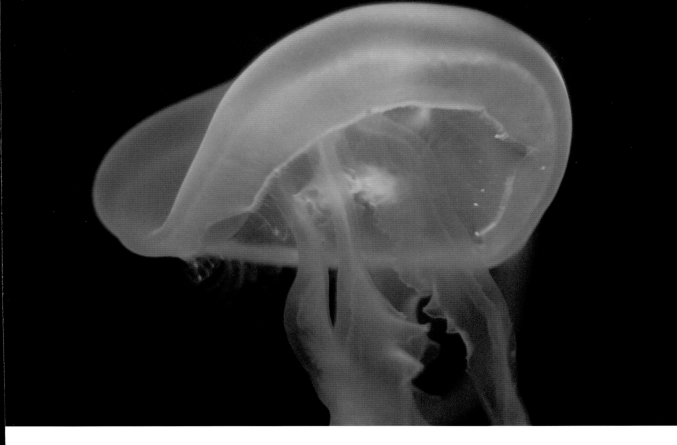

Irukandji Jellyfish, Box Jellyfish and others
Including the genera *Malo* and *Carukia*

Perhaps among the most unsettling of all deadly creatures are these tiny Irukandji Jellyfish, which average only about 1 cubic cm (0.06 cubic in) in volume and are essentially translucent. A swimmer, snorkeler, or scuba diver may not even be aware of the presence of one or hundreds of these small Jellyfish before swimming into one or dozens of these nearly invisible Coelenterates and suffering their stings. Other Box Jellyfish are larger, with the 'box' up to 30cm (12in) in diameter and tentacles up to 3m (10ft) long. All Jellyfish possess special stinging cells, called nematocysts, which fire venom-packed tiny barbed darts into the skin or the mouths of their attackers. Jellyfish have a highly unusual life cycle involving both sexual and asexual reproduction, the latter where a polyp sheds off tiny miniature Jellyfish, and eruptions of thousands of these invertebrates may result. Encountering one or a group of these Jellyfish can be fatal, or result in a temporary condition known as Irukandji syndrome, characterized by a sense of depression and doom.

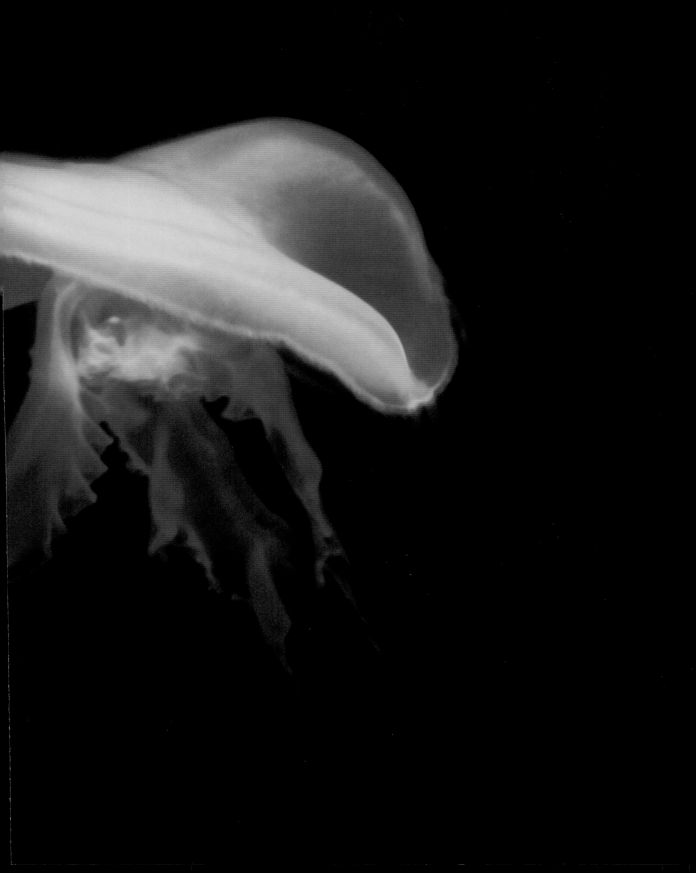

Man of War
Physalia utriculus, P. physalis and other species

By some measure this is the largest of all the deadly creatures, as this organism can grow up to 50m (164ft) in length! That length, however, is mostly comprised of thin, string-like tentacles that the Man of War dangles into the sea where its stinging nematocysts capture fish or other unwary prey. Sometimes tentacles break off and become free-floating stinging strands, and it is often these that swimmers and snorkelers encounter, suddenly experiencing sharp pains as a tentacle bumps against them. Further stings may occur as the swimmer reaches to pull the thread off the skin, as each strand is loaded with hundreds of venom-laden nematocysts. Most times, these stings are not fatal, although they can cause extremely severe pain, especially if a swimmer encounters an entire mass of tentacles. Man of Wars, named after the old sailing ships of the same name, have an air-filled jelly-like sack that acts like a sail and helps propel them through the sea, occasionally resulting in a mass beach stranding. Since the stinging cells remain active even on dry land and the tentacles may stretch for several metres, a beached Man of War or a mass stranding can present very dangerous conditions, often requiring a beach to be shut down for several days.

Blue-ringed Octopuses
Hapalochlaena species

While tales of deadly Giant Squids and Giant Octopus may morbidly titillate the imagination, a much smaller Cephalopod, or 'head-footed' animal, is far more dangerous to humans. The small, up to 20cm (8in) long, Blue-ringed Octopuses inhabit coral reefs in the Indian and Pacific Oceans, where they hunt for small crustaceans, crabs and fish. Like all Octopuses, these well-camouflaged hunters are non-aggressive but they will bite if disturbed, and the bony beak may nick a finger or hand, often without the victim being aware of the wound until deadly symptoms develop. The Octopus's venom is sufficient to kill 26 humans within minutes, and there is no antivenom for the bite. Again, the lesson here is to leave these animals alone, and keep your hands to yourself.

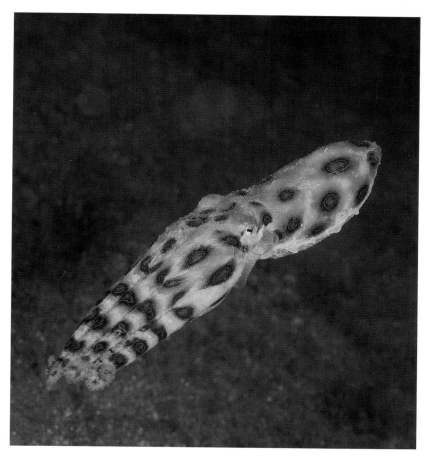

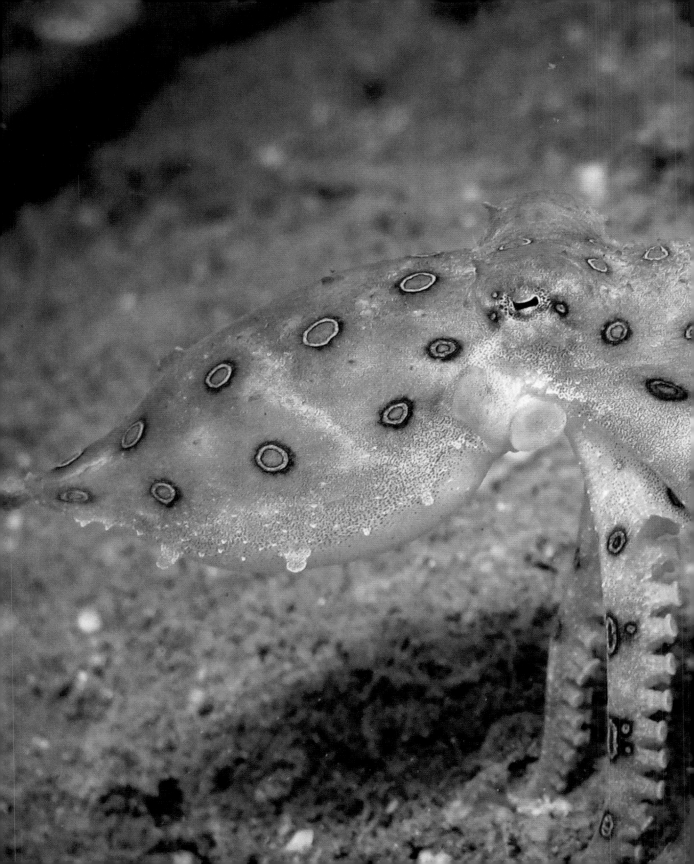

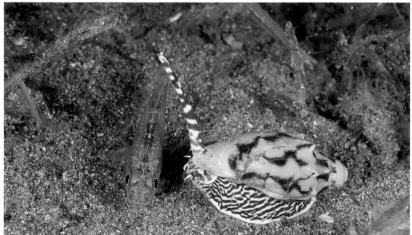

Cone Shells
Conus species

One wouldn't expect an attractively patterned sea snail to be deadly but the Cone Shells possess a venomous tooth or dart that they use like a harpoon to capture fish, or to protect themselves when necessary. Most stings to humans occur when someone picks up one of these colourful snails for a closer inspection. The barbed dart of the larger species can penetrate skin or even a scuba diver's glove and the dart possesses a lethal quantity of venom, causing death from respiratory failure.

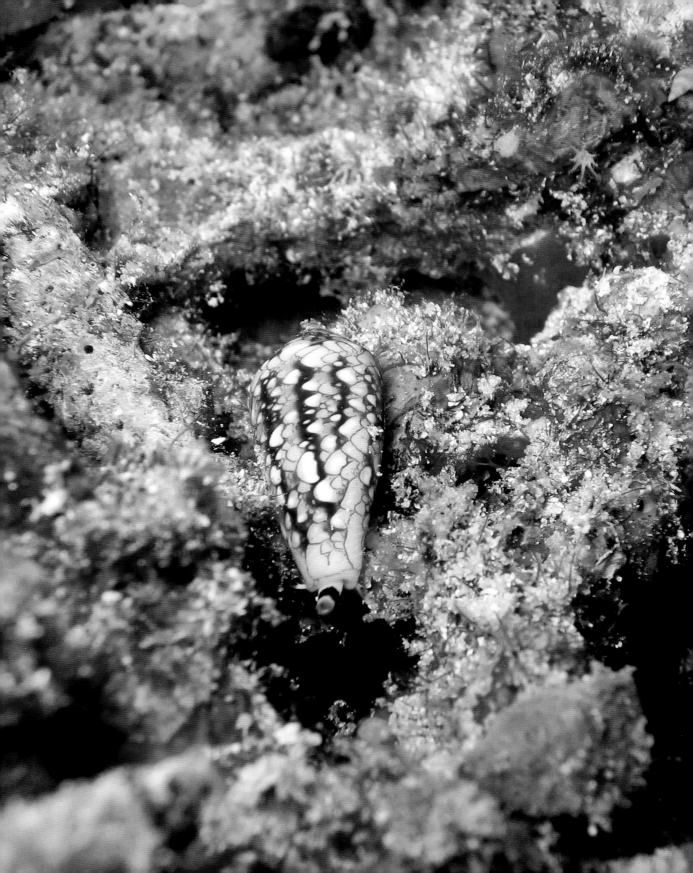

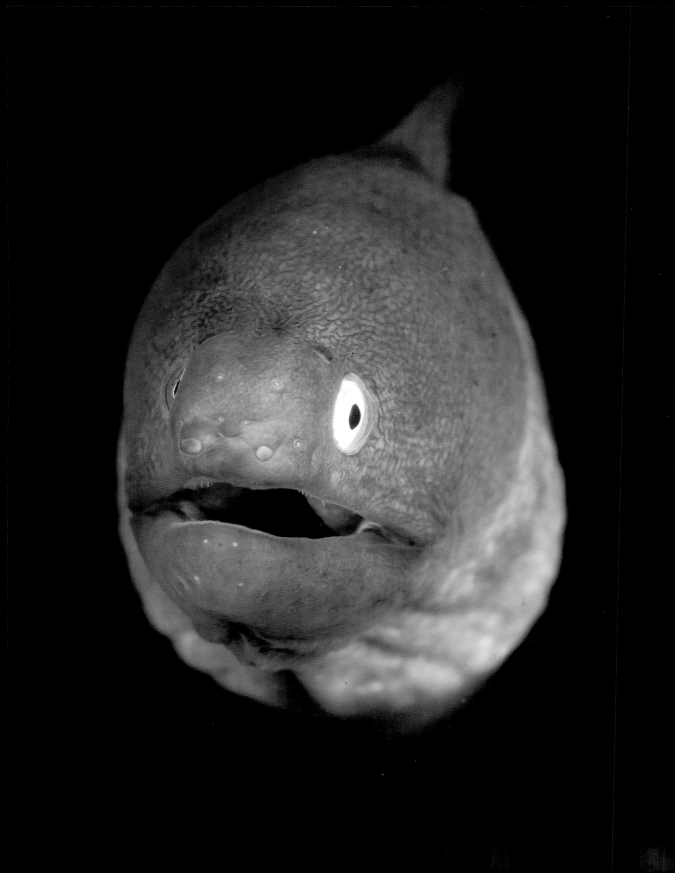

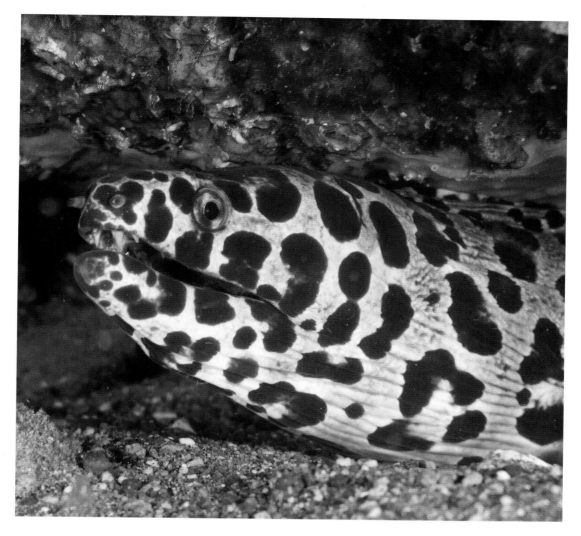

Moray Eels
Gymnothorax pictus and other species

While no one is known to have been killed by one of these large, toothy eels, the potential exists for the imprudent snorkeler or diver. Moray Eels have a fearsome but undeserved reputation, and will generally retreat backwards into the burrows and crevices they use to ambush prey. Moray Eels are sometimes fed by divers, and occasionally, either by accident or due to harassment, an eel will bite, and with its sharp, recurved teeth the eel is extremely difficult to remove. A large eel, up to 4m (13ft) long and with most of its body firmly wedged inside a burrow or crevice, could hold a snorkeler fast, and cause a drowning.

DEADLY
INVERTEBRATES

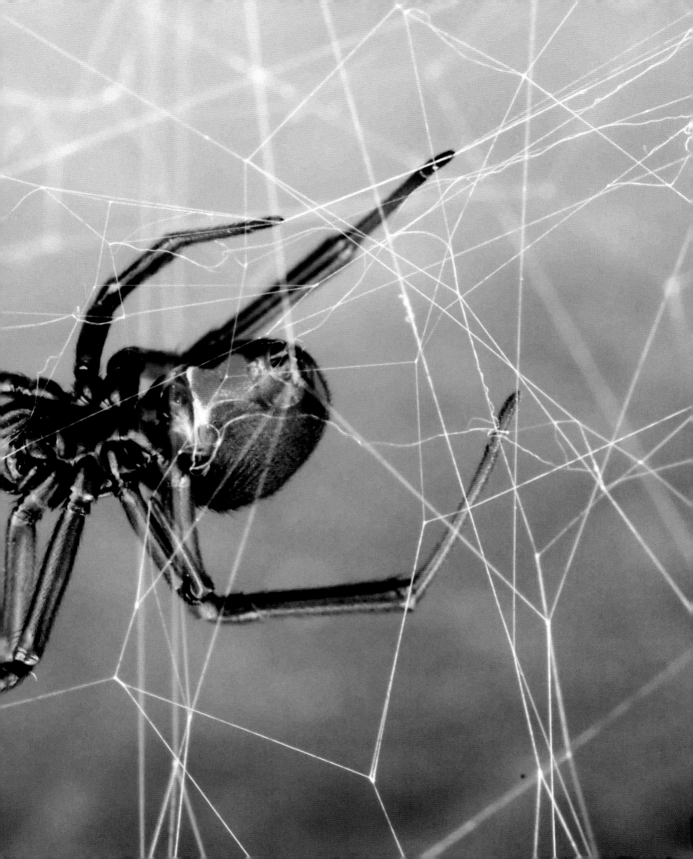

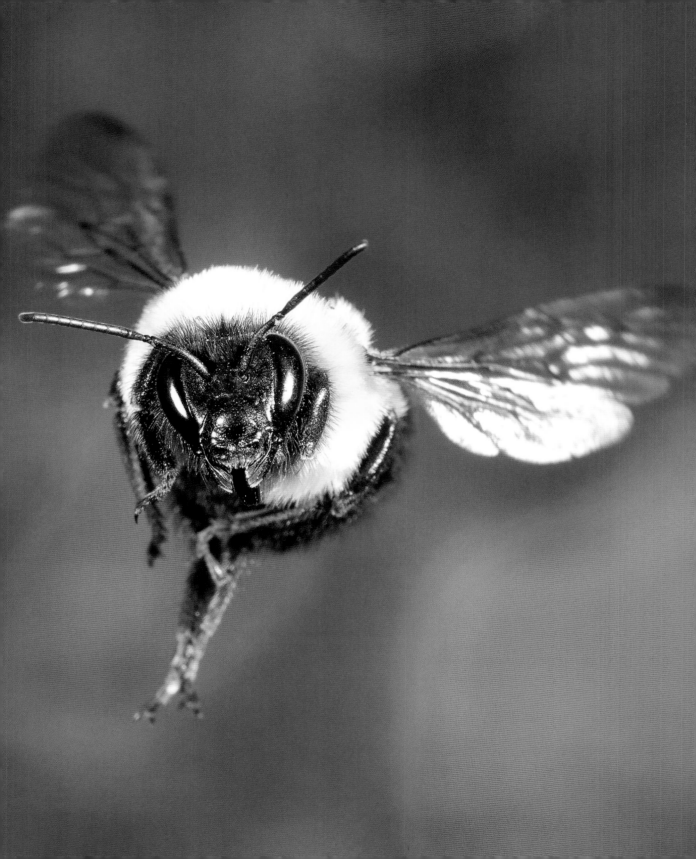

CHAPTER FIVE
DEADLY INVERTEBRATES

I had just pulled my car into a space beneath a large fruit tree that offered some shade on this summer's day. When I stepped out of the vehicle I felt several objects striking my back, and I was puzzled for a moment, until my eyes focused on the swirl of objects around me. Paper Wasps! Rather than jumping back into the car, and perhaps being stuck inside with several angry insects, I ran, and back then, luckily, I was pretty fast. I looked back as I sprinted down a country lane, scared into an even higher gear when I saw wasps still in the air in pursuit. I got away, but not before three or four wasps drove their stingers into my back, literally spearing me as I yelped in pain.

Truly an entire book could be devoted to the insects, spiders, scorpions, snails and other small and often unnoticed creatures that either pack a venomous sting or transmit a disease that ends in human fatalities. The annual death toll from just one snail-borne disease, schistosomiasis (or bilharzia), is more than double, and perhaps even quadruple the number of deaths resulting from venomous snake bites. Mosquitoes, those ubiquitous

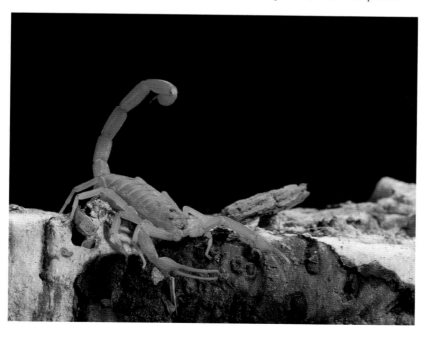

blood-sucking pests, transmit malaria, killing nearly three-quarters of a million people each year, along with transmitting a variety of other fatal diseases, including encephalitis, yellow fever, dengue fever and several others. Ironically, while there are no insects that could possibly prey upon man directly and cause a fatality, countless insects, ticks, mites and more all regularly use humans as a food source for at least a part of their life cycle, and in doing so may also cause people to die from the diseases they transmit.

Through their bites or stings, all delivered defensively, various spiders, scorpions, bees and wasps have the potential of being quite deadly. Each year in the United States one or two people, and sometimes several more, are killed by African Honey Bees when a hive is disturbed, and scores of people die simply from anaphylactic shock, an allergic reaction to a bee or wasp sting. Ticks, creepy spider-like arthropods that attach themselves to a variety of hosts and suck blood, transmit a variety of diseases, including Rocky Mountain Spotted Fever and Lyme Disease, afflictions that may not be fatal in themselves but can weaken victims sufficiently to create further life-threatening problems.

Although I implicated Black Rats with the bubonic plague and 'black death' of the Middle Ages, the little Fleas these Rats carried were the real villains, as their bites transmitted the bacteria responsible for a disease that wiped out more than half the human population of Europe. Indeed, the more one knows about the variety of invertebrates that can do us harm the less one might be inclined to wander outdoors, for it sure seems to be a dangerous and deadly world out there!

DEADLY INVERTEBRATES
THE SPECIES

Redback Spider
Latrodectus hasselti

Black Widow Spider
L. mactans and related species

Worldwide, there are a number of potentially deadly spiders, all belonging to the same genus and often known as the Widow Spiders. This common name is not because these spiders make widows of unlucky human victims, although they indeed can and do, but because of the female's habit of eating her mate during or after copulation. A Redback Spider male will often assist in this gruesome endeavour, placing his abdomen within easy reach of the female's jaws, perhaps to sate the female's desire to mate with other males later on. The Widow Spiders make a rather messy looking web, often doing so underneath picnic tables or chairs, and under toilet seats in outhouses, much to the horror and surprise of some victims of their bite. Most bites are not fatal but can be extremely painful, with the effects of the bite lasting as long as a month. One Arachnologist, a scientist specializing in spiders, purposely allowed himself to be bitten by a Black Widow to experience and record the effects. It was not too many minutes after being bitten that he stated that the decision was one of the dumbest ones he'd ever made, as the pain was truly excruciating. Like most victims, he did recover.

Funnel–web Spider
Hadronyche modesta

Brown Recluse Spider
Loxosceles reclusa

The relatively large, 2cm (0.8in) long Funnel-web Spider has the very disturbing habit of hanging on and biting repeatedly when annoyed or corned, the most likely reason for this spider to actually bite a human. The bite can be very dangerous, with a fatal bite potentially taking effect in as little as 15 minutes. Distantly related to the Tarantulas, Funnel-web Spiders have large and sturdy fangs said to be powerful enough to go through a fingernail or a shoe. Tarantulas, which do in fact look somewhat similar, generally lack deadly venom, but the bites of some, such as the giant Baboon Spider, *Pelinobius muticus*, of East Africa may be as painful as the bite from a Rattlesnake, although not with the same fatal consequences. Another nefarious Spider, the Brown Recluse Spider of the southern United States, in contrast, has a nearly painless bite and some victims are unaware they were even bitten. Although most Brown Recluse bites are not fatal for humans, nearly one-third of bites result in some type of tissue necrosis, sometimes with the wound not healing for months.

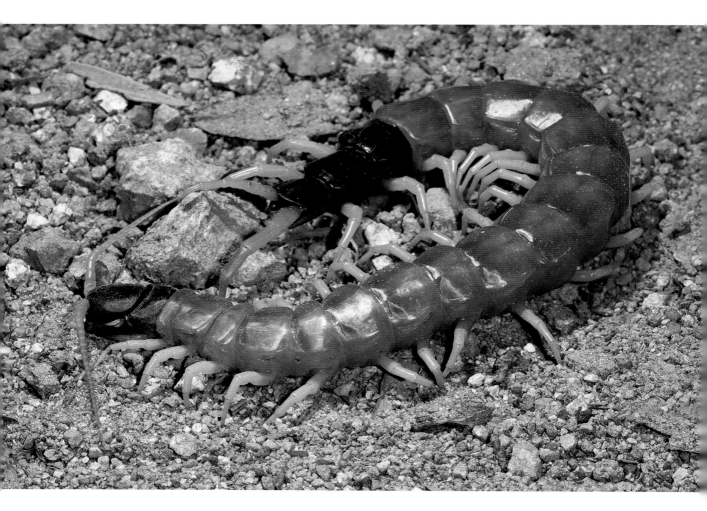

Giant Desert Centipede
Scolopendra heros

Through a car's headlights on a desert road in southern Arizona one might see a fast-moving, snake-like critter undulating across a desert road at night. Nocturnal, the Giant Desert Centipede roams across the desert floor looking for small arthropods, small snakes and nocturnal Banded Geckos which this large Centipede subdues with a venomous bite. There are over 8,000 species of centipedes, all characterized by having just one pair of legs per body segment. The somewhat similar-looking but slower-moving millipedes have two pairs of legs per segment and are more worm-like in appearance, while some centipedes resemble long, many-legged insects. A bite from a large centipede can be quite painful, but is normally not fatal unless the victim goes into anaphylactic shock, the common cause of many insect-induced fatalities.

African Honey Bee
Apis mellifera scutellata

These are the deadly 'Killer Bees,' feared because of their aggressive nature when defending their hives, when workers may disgorge from a hive in four times the number that the less aggressive European Honey Bee might field. Escaping from a research facility in Brazil and rapidly spreading northwards, the African Honey Bee has become a pest in parts of Central America and the south-western United States as the bees often swarm on buildings. Forming a temporary mass of thousands, bees may attack anyone or anything if the swarm is approached too closely or if the swarm or hive is disturbed. While an individual sting of any Honey Bee is not lethal, unless the sting triggers an anaphylactic shock reaction, the African Honey Bee may attack in large numbers, sometimes pursuing their threat for over 1km (0.6 miles). Five hundred stings, each one its own painful stab, may be sufficient to kill an adult.

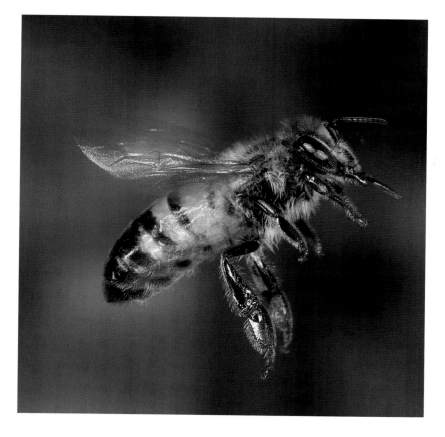

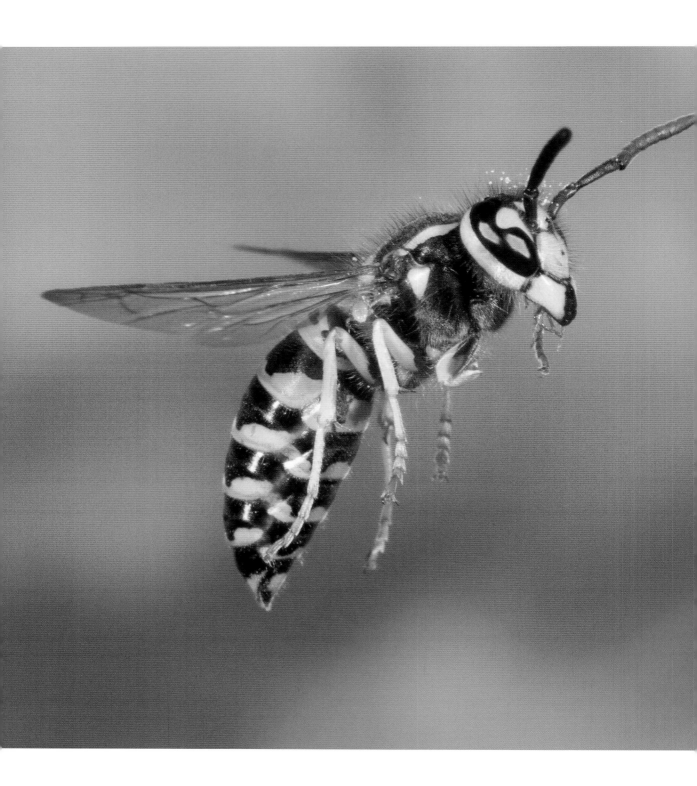

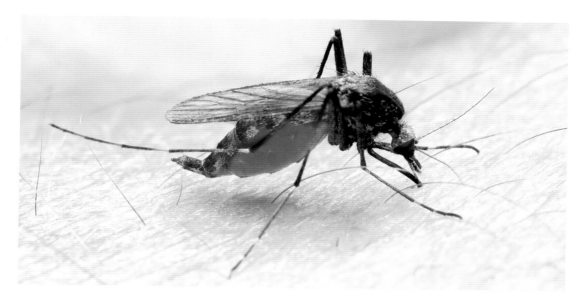

Yellowjacket
Vespula maculifrons

The Yellowjacket is just one of a number of
colonial wasps and hornets that can make one's
life miserable, especially at an outdoor picnic
when a slice of fruit or a sugary drink has an
unseen diner aboard. Unlike a Honey Bee that
only stings once, since the barb is ripped out of
the bee's abdomen upon stinging anyone, wasps
and hornets can sting repeatedly. Nest colonies
of Yellowjackets may contain as many as 5,000
adults, and should one of their underground nests
be disturbed, as may happen to an unfortunate
gardener, a very painful experience will follow.
Individual stings are not fatal unless anaphylactic
shock is involved, but the stings from scores or
hundreds have caused fatalities.

Mosquitoes
Family Culicidae

Mosquito-borne diseases kill nearly three-
quarters of a million people per year around the
world. These insects can carry life-threatening
diseases such as malaria and dengue fever. Not
all mosquitoes are villains, however, as only a
small proportion of the 3,500 described species
are dangerous to humans, transmitting disease
as the females of those species suck blood from
their unwitting host, inoculating the host as they
do so. Malaria, the chief killer, is caused by the
introduction of a microscopic protozoan that
attacks red blood cells and may affect as many
as half a billion people each year. Unlike almost
all of the other creatures described in this book,
where one can usually avoid meeting up with a
deadly creature, it is nearly impossible to do that
with a mosquito. They are everywhere, including
in the high arctic where they can number in the
trillions, although those species are only biting
pests and are not transmitters of most diseases.

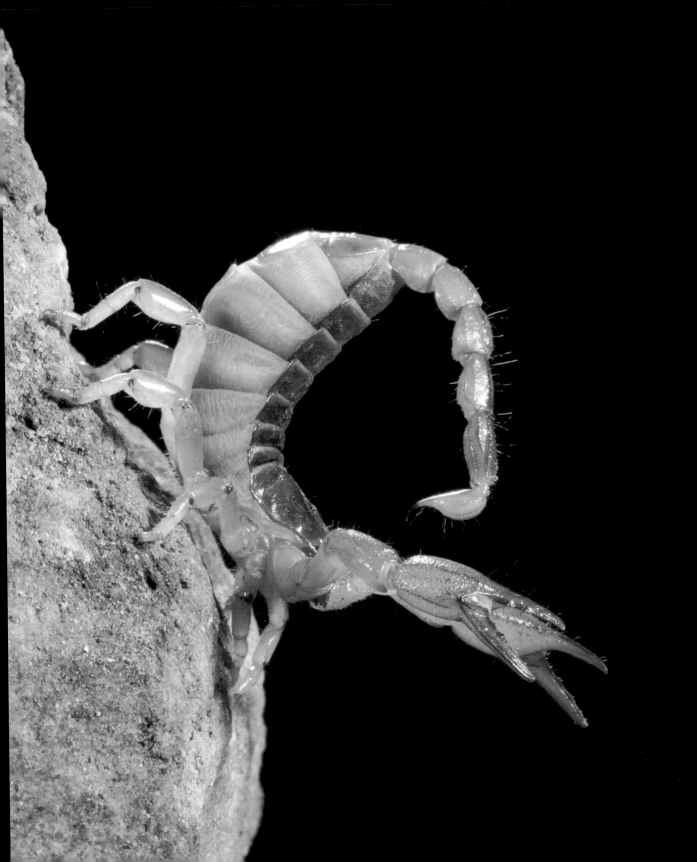

Bark Scorpions
Centruroides species

Deathstalker Scorpion
Leiurus quinquestriatus, and other species

Over 3,000 people die each year from a Scorpion sting. These arthropods are distinctive, with crab-like pincers and a long, segmented tail tipped by the sharp stinger, and although nocturnal they are found on every continent except Antarctica. Scorpions have the unsettling habit of seeking cracks and crevices and other hiding places at dawn, after their night of foraging, and their shelter may end up being your shoe, pants leg or shirt! Scorpions can occur in surprisingly large numbers, revealed to the curious if you use an ultraviolet light and scan the ground and bushes, as scorpions glow an unearthly green under the UV light. Most scorpions only deliver a painful sting but a few species, including the Bark Scorpions and the Deathstalker Scorpion, can deliver a fatal sting.

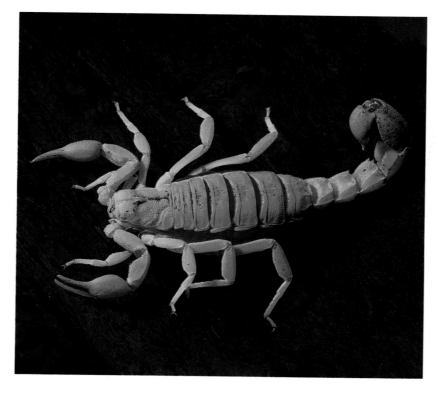

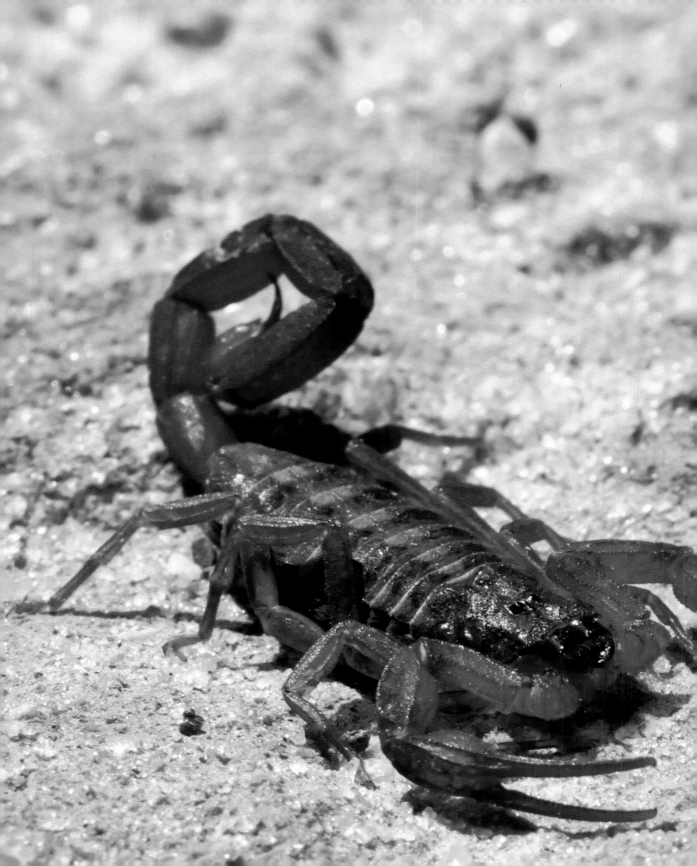

Australian Paralysis Tick
Ixodes holocyclus

Perhaps the ultimate bane of the outdoors is the tick, which is found worldwide on all continents except Antarctica. Ticks wait in ambush on blades of grass, leaves and bushes, their tiny arms outstretched, waiting for a reptile, bird, mammal, or for you to walk by, whereupon they release their grip on their perch and begin their next journey, seeking a spot where they can suck blood. Ticks often transmit disease, and the Australian Paralysis Tick is named for the systemic paralysis it can cause. In North America, ticks transmit Rocky Mountain Spotted Fever and Lyme Disease, debilitating diseases that may not be fatal but may weaken the host, making them susceptible to other illnesses. Female ticks will ride their host until they have consumed enough blood, whereupon they drop off and, in the case of the Paralysis Tick, lay as many as 6,000 eggs over a period of several days.

CHAPTER SIX
THE MOST DEADLY CREATURE OF ALL

While a wide variety of animals in the wild world can do us harm, the most deadly animal of all neither slithers, creeps, crawls, flies, or walks on four legs, but instead it is a two-legged animal, and it is most certainly not a bird. The most deadly creature of all is *Homo sapiens*, or Humans, an extremely dangerous animal that threatens the existence of so many other species while also posing the most dangerous threat to members of its own species.

Humans have been the most deadly of creatures practically since day one, when small bands of *Homo sapiens* journeyed out of Africa on what was to become an expansion of range that would literally encompass the world. It is probably not a coincidence that many species of large mammal, reptile and bird disappeared at approximately the same time that modern humans advanced into new areas. In North America, the vast mammal megafauna that put Africa's diversity to shame disappeared between 12,000 and 10,000 years ago, coinciding with humans' migration into this continent. In Australia, the extraordinary diversity of large marsupial mammals constricted to what we have today around 60,000 years ago, coinciding once again with the advent of humans upon that continent. Bone middens, the ancient trash heaps of discarded bones from countless meals, record the prehistoric intrusion of humans into Oceania and reveal that an astonishingly large number of bird species have disappeared since people settled these islands. In New Zealand, giant ostrich-like birds, the Moas, disappeared within centuries of these isolated islands being settled by humans. A similar pattern occurred with the huge Elephant Bird, Lemur species as large as Gorillas and Orangutans, a Hippopotamus, and multiple other species on the island continent of Madagascar, also disappeared shortly after humans made an appearance.

In North America, once the immigrants to the 'western world' began to spread across the continent, the world's most abundant bird, the Passenger Pigeon, began its slip towards extinction. At one time, this Pigeon occurred in such high numbers that migrating flocks literally blocked the sun, and their passage across the skies was often measured in days. Yet it took less than 500 years from the time Christopher Columbus stepped upon an island

in the Bahamas to the sad day when the last Passenger Pigeon died in a Cincinnati Zoo. Bison, whose numbers may have exceeded 50 million on the Great Plains of North America, were reduced to a few dozen animals before protection halted their plummet to extinction.

Humans haven't been kind to their closest relatives either. As modern humans spread across the globe, other species or subspecies of humans disappeared, most famously the Neanderthal of Europe and Western Asia. In the modern world, horrific intraspecific wars, a behaviour unknown in any other animal, have wiped out as many as 80 million people in World War II, 17 million in World War I, and uncounted millions more in the 3,000 or 4,000 years of modern 'civilization.' Today, nearly 750,000 people die of violence each year, from war or murder.

Still, despite these losses annually and through periodic wars, humans have prospered and now reside, in one way or another, on every continent on Earth. And in doing so, the wild world has suffered, so much so that many scientists believe we are witnessing what has been called the Sixth Extinction. Five previous times the diversity of life on Earth was severely reduced, the most recent and most famous being the big extinction event at the end of the Mesozoic Era, the Cretaceous Period, when nearly all Dinosaurs died out, survived only by what are now the modern birds. In the case of that extinction, a six-mile wide asteroid smashed into Earth, and it must be presumed that the other four mass extinctions also had some natural explanation.

Not so the Sixth Extinction, which in one way or another appears to be caused by humans. Since 1500, 875 extinctions have been documented, with an unknown number of other species vanishing without any formal record. Today, the extinction rate is dizzyingly rapid, perhaps as many as 140,000 different species lost forever, every year! Many scientists predict that by the year 2100, if present trends continue, as many as half of Earth's higher life forms, that is birds, amphibians, mammals, larger arthropods and so on, will be gone, as will countless more unnamed 'lower' forms of life.

In the not too distant past, these extinctions were the direct result of the greed and rapacity of humans. The Great Auk, the Dodo, the Passenger Pigeon, the Elephant Bird and the Moas were all hunted to extinction. In modern times, new threats from humans have impacted upon the world's wildlife, most notably from climate change and from habitat loss. Extinction is a natural process, but until relatively modern times the number of species that became extinct was offset by the evolution of new species. Scientists have calculated the natural extinction rate, termed the background extinction rate, and based on this rate nine vertebrates would be expected to have passed

into extinction since the year 1900. Instead, 468 species of vertebrates have vanished forever during that time, and modern rates are very conservatively calculated at between 8 and 100 times faster than that background rate.

Just consider some of the deadly creatures mentioned in this book. In southern Africa a Rhinoceros is poached every 18 hours and soon, at the present rate of attrition, they will become extinct in the wild. African Elephants, numbering many hundreds of thousands not too many years ago, are now reduced to 500,000 or less, and although that seems like a large number still, rampant poaching is rapidly shoving these survivors towards the brink. African Lions are declining fast, and their population is now one-tenth the size it was 30 years ago. Another charismatic megapredator, the Tiger, has been reduced to a population of less than 4,000 spread throughout Asia, and this depressing list goes on and on. A warming climate is also changing the wild world, pushing some cold-loving animals to higher elevations or latitudes and nudging far more of those species closer towards oblivion. The Chrytid fungus, probably spread worldwide inadvertently by humans, is wiping out the entire Amphibian Class, with fully one-third of all species of frogs and treefrogs now in danger of extinction, and many species have already passed out of existence. Insect-eating Bat populations in eastern North America are now reduced by 95 per cent or more from the devastating White-nose Syndrome, a deadly fungus that was probably transported from Europe to America by spelunkers. If bats do survive this plague it will take decades for their populations to recover to anything close to their former numbers.

Today, about half the land on earth is occupied or utilized by humans, and the remaining wild lands are rapidly disappearing. Cumulatively, worldwide, forest acreage the size of Massachusetts disappears every day, and since much of this occurs in the tropics, in the areas of habitat hosting the greatest species diversity, unknown numbers of animals disappear with these vanishing forests. The sheer vastness of this forest devastation is practically incomprehensible. Consider, in just nine years, an area the size of Spain was cleared of forests in the Amazon Basin. In much of South-east Asia, coastal South America and coastal East Africa, Madagascar, and even the state of California, forest habitats are now only 10 per cent of their original size.

As the human population continues to grow and the need for more food and living space and a desire for a better standard of living puts more pressure on the wild world, the prospects of having a rich and diverse world filled with animals like those mentioned in this book are poor. The diversity of life is vanishing before our eyes, thanks in large part to humans, the most deadly creature of all.

INDEX

Roman = Common name
Italic = Latin name
Bold = illustration